ICONS

Erotica
19th Century

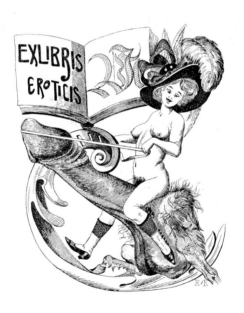

Gilles Néret

Erotica

19th Century

From Courbet to Gauguin

TASCHEN

KÖLN LONDON MADRID NEW YORK PARIS TOKYO

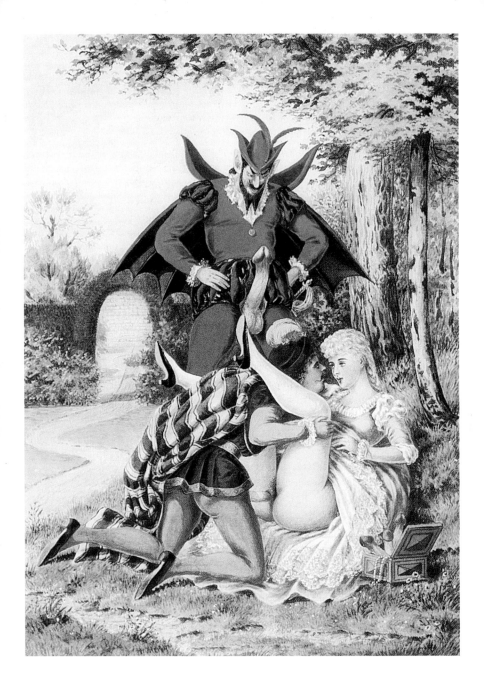

4·5 **Anonymous** Victorian lithograph, late 19th century

Catching the Devil by the Tail

The 19th century just looks like Monsieur Ingres himself, a wealthy member of the middle classes associated with 'virtuous art' and Raphaelesque purity, the leading exponent of the classical school, and yet an artist whose innermost fantasies and secret obsession with women surfaced time and time again, despite his best efforts. 'M. Ingres', as Baudelaire roguishly noted, 'was never happier or more compelling than when his talent had to contend with the charms of a young beauty...' From his youthful notebooks, inspired by classical erotic pictures, to his unexpected and sensuous masterpiece, *Le Bain turc* (The Turkish Bath), painted when he was eighty-two, he treated spectators to a dazzling display, virtually unparalleled in its audacity, of women offering themselves up, caressing themselves or each other, embracing, waiting to be pleasured or, with their eyes shut, savouring the memory of past carnal delights.

However, although Ingres's secrets were given away by his art, the society to which he proudly belonged took painstaking care to ensure that its vices were protected by a cloak of silence. Nothing was taboo so long as it remained hidden. Once again, the artists were the ones who dared to violate the official taboos and wage war on widespread hypocrisy. Although traditionally in opposite camps, the romantic dreamers who wanted to transform reality and the supporters of realism who wanted to portray modern life became impartial allies, joining forces to lead a rebellion against the social conventions of a commercial and industrial bourgeoisie which sought, in the name of decency, to deny its secret vices. The noble style modelled on the art of Ancient Greece and Rome was rejected in favour of an out-and-out aesthetic revolution that signalled the use of coarse, everyday elements in art and proclaimed the pressing need to tell the truth.

The subject of art moved from *Venus* rising from the waves to *Nini* rising from her bed. Delacroix illustrated the escapades of Goethe's Faust and depicted the triumphant breasts and hairy armpits of a vigorous woman of the people called *Liberty*; Courbet painted the gaping cleft of the female sex organ, entitling the picture *The Origin of the World*; and Millet and Daumier showed the peasants and lower classes merrily copulating, a realistic brand of voyeurism that reached its height in brothel scenes by Degas and the amorous revels of Gauguin's 'noble savages'.

Romanticism reinstated the figure of medieval Satan and brought the Devil down from the Gothic gargoyles, while demons and witches capered shamelessly around the large black goat inherited from Goya. To the great displeasure of the respectable classes, the Devil acquired a new lewd and bawdy side to his character in the work of artists like Devéria and Le Poitevin. A certain Peter Fendi illustrated this return to pagan sources, to Pan, the Cabeiri and the phallus. Gigantic, tumescent, Herculean, ready to do battle, the phallus is actually the true hero of these pictures which aim to excite open mirth.

Artists who preferred to remain anonymous rather than risk imprisonment produced some invaluable illustrations providing an insight into the secret vices enjoyed by the hypocritical moneyed and bourgeois classes. Lithography, which was becoming increasingly popular, denounced the private clubs frequented by members of the new ruling class who imposed a conspiracy of silence on sexuality and yet who indulged freely in innocent children's games, from 'blind man's bluff' to 'hot cockles', altering their rules to transform them into orgies. Masterpieces like Flaubert's *Madame Bovary* and Baudelaire's *Les Fleurs du Mal* were brought before the courts for obscenity, Oscar Wilde was sent to prison for homosexuality, but people still secretly visited the Flagellant Society.

Romanticism took the form of supreme decadence in the restless and obsessive *fin-de-siècle* years which preceded a healthier Belle Epoque. A new race of dandies, from Aubrey Beardsley in London to Félicien Rops in Namur, took up the fight against social hypocrisy, portraying dissolute behaviour with great relish. These artists justifiably felt that sexuality had always been one of the mainstays of human existence as well as one of art's main sources of inspiration. They used sophisticated weapons making the most shocking subjects appear as beautiful as possible. They described the woman's body and its attributes like a gorgeous exotic flower with a deadly tarantula lurking at its heart. Convinced that women were essentially diabolic, that their tempting charms were a gift of the devil – an erotic constant of Symbolism –, these Decadents flirted extensively with Satanism, satirising and parodying bourgeois sexuality by creating something similar to a catalogue of Freudian ideas before that term ever existed. J.-K. Huysmans, whose work Rops illustrated, paid tribute to him in these terms: 'He painted demonic ecstasy as others have painted transports of mysticism ... in a word, the supernatural face of perversity, the other side of Evil.'

Jean-Auguste-Dominique Ingres Femme lutinée par l'Amour, 1800–1806

Paul Gauguin Maori Lovers, 1891

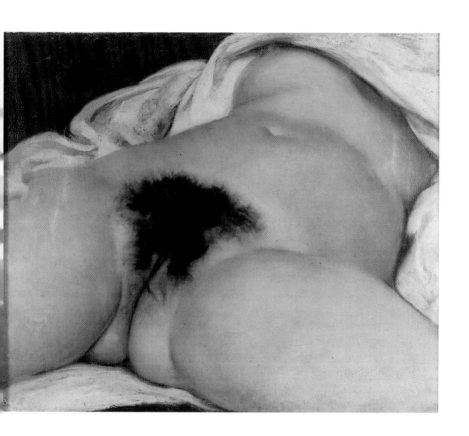

Gustave Courbet The Origin of the World, 1866

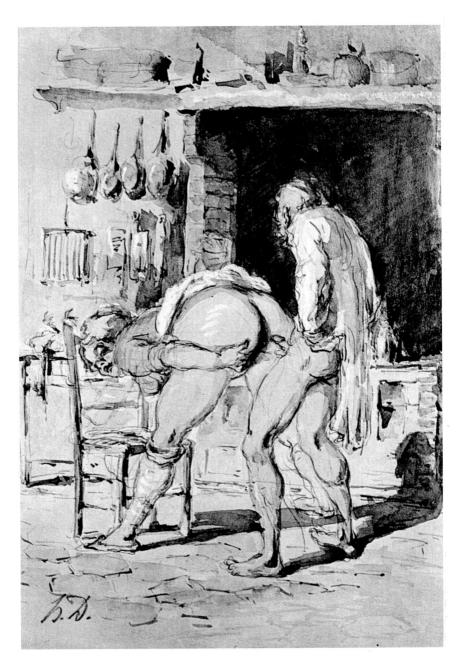

Honoré Daumier At Home with the Peasants, c. 1834

Den Teufel beim Schwanz packen

Das neunzehnte Jahrhundert war ganz nach dem Geschmack von Monsieur Ingres, dem Großbürger und Verfechter einer „tugendhaften Kunst" von der Reinheit eines Raffael. Gleichwohl übte der Hauptvertreter der klassischen Schule sein Leben lang Verrat am eigenen Ideal, ließ er doch seinen intimsten Wunschvorstellungen und seinen verborgenen Obsessionen freien Lauf. Berechtigterweise und nicht ohne Bosheit notiert Baudelaire: „Niemals beweist Monsieur Ingres eine so glückliche Hand und so viel Könnerschaft, wie zu den Zeiten, als sein Genie sich von den Reizen einer jungen Schönheit gefangen fühlte ..." Angefangen bei seinen Skizzenheften aus der Jugendzeit, die von antiken erotischen Darstellungen inspiriert sind, bis zu seinem verwegenen und rauschhaften Meisterwerk *Das türkische Bad*, das er mit 82 Jahren malte, inszenierte Ingres in seinem Werk ein Fest der Sinne, das an Kühnheit kaum seinesgleichen findet: ein wahres Panoptikum der Frauen, die sich darbieten, sich einander zärtlich zuwenden. Sie erwarten den Augenblick der Lust oder geben sich mit geschlossenen Augen der Erinnerung an die Wollust hin.

Die Geheimnisse des Malers Ingres mögen sich in seiner Kunst offenbaren, aber die Gesellschaft, der anzugehören er sich gerne rühmte, wachte eifersüchtig darüber, dass der Mantel des Schweigens ihre Schändlichkeiten verhüllt und verbirgt: Alles ist erlaubt, aber nur unter der Bedingung, dass es im Verborgenen geschieht. Wieder einmal sind es die Künstler, die es wagen, die offiziellen Tabus zu brechen und der überall herrschenden Scheinheiligkeit den Krieg zu erklären. Die romantischen Träumer, die die Realität transformieren wollen und ohnehin eine oppositionelle Rolle einnehmen, und die Verfechter des Realismus, die dem modernen Leben Ausdruck verleihen wollen – diese so gegensätzlichen Geister machen gemeinsame Sache und zetteln eine Revolte an gegen die gesellschaftlichen Konventionen einer Bourgeoisie aus Industriellen und Kaufleuten, die im Namen der Dekadenz alles daran setzt, die Perversitäten zu verschleiern, die sie insgeheim begeht. Man lässt die griechische und römische Antike, deren edler Stil bis dahin prägend gewesen war, hinter sich zugunsten einer totalen ästhetischen Umwälzung, mit der das Vulgäre und Alltägliche Einzug in die Kunst erhält und die lange fällige Forderung erhoben wird, endlich die Wahrheit zu sagen.
Vorbei an *Venus*, die den Wellen entsteigt, hinüber zu *Nini*, die aus ihrem Bett steigt ... Es sind Delacroix' Illustrationen zu Goethes *Faust* oder seine

robuste Frau aus dem Volke, genannt *Die Freiheit*, die triumphierend ihre Brüste und ihre behaarten Achselhöhlen zeigt; es ist aber auch das weibliche Geschlecht, das Courbet den Augen des Betrachters offen darbietet, von ihm selbst *Der Ursprung der Welt* genannt; es sind die Bauern und die kleinen Leute von Millet und Daumier, die fröhlich vor aller Augen kopulieren – sie alle bedienen einen realistischen Voyeurismus, der in den Bordellszenen von Degas und den munteren Spielen der „edlen Wilden" von Gauguin seinen Höhepunkt findet.

Die Romantik lässt die Figur des mittelalterlichen Satans wieder aufleben und den Teufel von den gotischen Wasserspeiern herabsteigen, während Dämonen und Hexen schamlos um den großen schwarzen Bock, ein Erbe Goyas, herumtanzen. Zum größten Missfallen der Bürger verleihen Künstler wie Devéria oder Le Poitevin dem Bösen lüsterne, schlüpfrige Züge, die es bis dahin nicht gegeben hat. Auch Peter Fendi illustriert diese Rückkehr zu den heidnischen Quellen, zu Pan, den Kabiren (den griechischen Fruchtbarkeitsgöttern) und Phalli. Als gigantischer Schwellkörper, kraftstrotzend, zum Kampf bereit, ist der Phallus im Grunde der wahre Held dieser Bilder, die nichts anderes als ein fröhliches und freies Lachen hervorrufen sollen.

Dank der Aufzeichnungen von Künstlern, die lieber anonym bleiben wollten, als ins Gefängnis zu gehen, verfügen wir über kostbare Illustrationen, die detailliert über die geheimen Laster der Wohlhabenden und der scheinheiligen Bürger Auskunft geben. Die Lithografie, die gerade ihre Blütezeit erlebt, macht die Leute mit jenen Privatclubs bekannt, die von eben jener neuen herrschenden Klasse frequentiert werden, die das Verschweigen alles Sexuellen verordnet hat; aber eben dort spielt man die unschuldigen Kinderspiele, zum Beispiel Blindekuh, jedoch „mit leidenschaftlicher Hand", nur hat man die Regeln so geändert, dass aus den Spielen wilde Orgien werden. Man zerrt so großartige literarische Werke wie *Madame Bovary* von Flaubert und *Die Blumen des Bösen* von Baudelaire wegen ihrer angeblichen Obszönität vor die Gerichte und wirft Oscar Wilde wegen seiner Homosexualität ins Gefängnis, aber bei Nacht und Nebel sucht man den Club der Flagellanten auf ...

Eine Jahrhundertwende, die kränkelt und vor Erregung vibriert, überführt die Romantik in ihre extreme Form, die Dekadenz, gibt aber schließlich den Weg frei für die Belle Epoque, die mehr Widerstandskraft beweist. Eine neue Spezies von Dandys, ob Aubrey Beardsley in London oder Félicien Rops in Namur, kämpft nun ihrerseits gegen die Scheinheiligkeit

ihrer Klasse, indem sie mit größtem Vergnügen und Genugtuung die lockeren bis verlotterten Sitten vorführt, aber zu Recht davon ausgeht, dass die Sexualität ein Grundelemenet des menschlichen Daseins darstellt und immer und zu allen Zeiten eine der wichtigsten Inspirationsquellen der Kunst war und ist. Ihre raffinierteste Waffe: das anrüchigste Sujet so schön wie möglich darstellen, den weiblichen Körper und seine Attribute mittels des Bildes einer giftigen Vogelspinne, die sich im Inneren einer wunderschönen exotischen Blume eingenistet hat, heraufbeschwören.

Diese Décadents, die davon überzeugt sind, dass die Frau in ihrem Wesen etwas Diabolisches hat, dass der Dämon sie als ständige Versuchung geschickt hat – eine erotische Konstante des Symbolismus –, diese Künstler der Dekadenz gehen mit dem Kult des Satanischen nach Art eines freudianischen Musterbuchs (ehe es den Begriff freudianisch überhaupt gab) sogar noch einen Schritt weiter, indem sie die bürgerliche Sexualität parodieren und in Satiren verarbeiten. J.-K. Huysmans preist Rops, der seine Werke illustrierte, mit folgenden Worten: „Er hat die dämonische Ekstase gemalt, wie andere die mystische Verzückung dargestellt haben ... kurz gesagt, das Übernatürliche der Perversität, das über das Böse Hinausgehende."

Henri de Toulouse-Lautrec (1864–1901) Love Pigging It

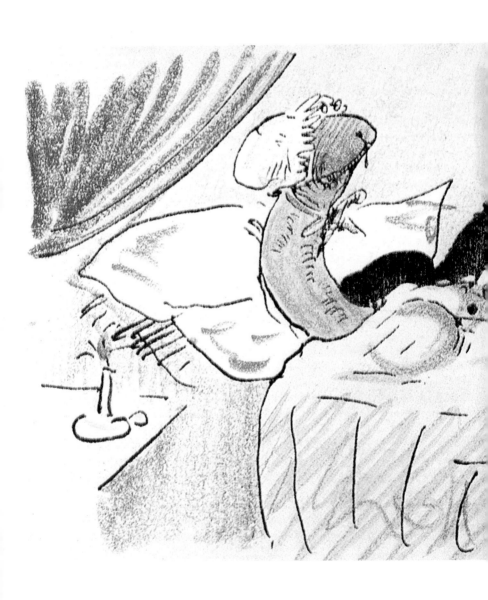

Henri de Toulouse-Lautrec (1864–1901) The Good Girl: she brings a tisane to her flu-ridden but not shapeless father

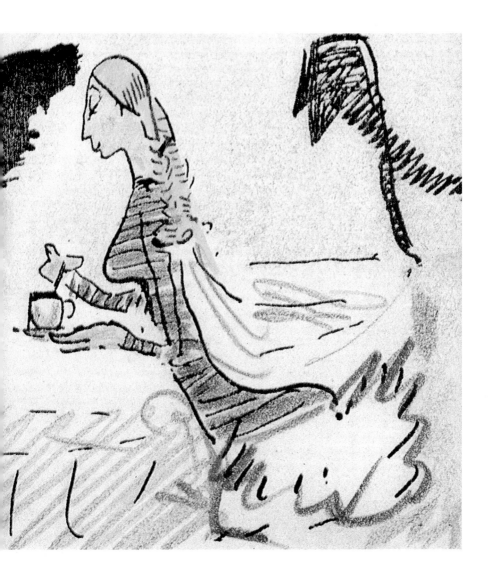

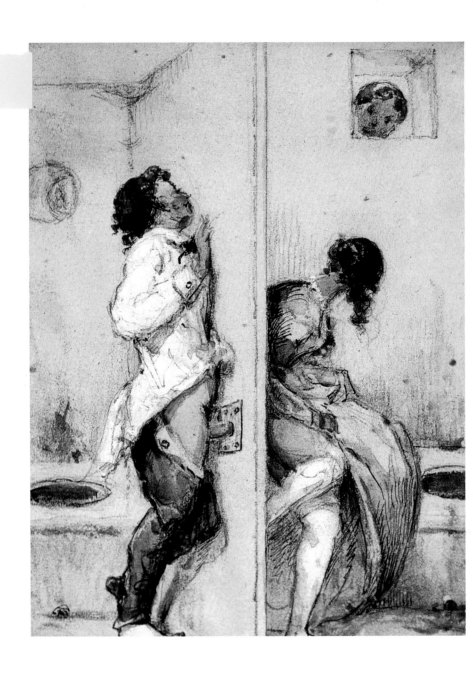

Paul Gavarni The Places ... of Pleasure, c. 1840

Le Diable par la queue

Le 19e siècle est à l'image de Monsieur Ingres, grand bourgeois attaché à « l'art vertueux », à la pureté raphaélesque, chef de l'école classique, qui se trahit tout au long de sa vie, en laissant parler, malgré lui, ses fantasmes intimes et son obsession cachée de la femme. M. Ingres, ainsi que l'a noté Baudelaire avec malice, « n'est jamais si heureux ni si puissant que lorsque son génie se trouve aux prises avec les appas d'une jeune beauté... » Depuis ses carnets de jeunesse, inspirés d'érotiques antiques, jusqu'à son insolite et capiteux chef-d'œuvre, Le Bain turc, peint à quatre-vingt-deux ans, il en résulte un festival d'une audace rarement égalée, une véritable anthologie de femmes qui s'offrent, se caressent, s'enlacent, attendant le plaisir ou se replongent, les yeux clos, dans le souvenir de la volupté.

Mais si les secrets de Monsieur Ingres sont trahis par son art, la société à laquelle il se flatte d'appartenir veille jalousement à ce que le manteau du silence recouvre et cache ses turpitudes. On peut tout faire, à condition que cela ne se sache pas. Une fois de plus, ce sont des artistes qui oseront briser les tabous officiels et partir en guerre contre l'hypocrisie générale. Pourtant opposés par tradition, mais devenus alliés objectifs, les rêveurs romantiques, qui veulent transfigurer le réel, et les adeptes du réalisme, qui veulent incarner la vie moderne, font cause commune et mènent la révolte contre les conventions sociales d'une bourgeoisie industrielle et commerciale qui cherche, au nom de la décence, à nier les perversités qu'elle pratique en secret. On quitte l'Antiquité grecque et romaine, qui avait jusque-là imposé son style noble, pour une révolution esthétique totale qui marque l'introduction du vulgaire et du quotidien dans l'art et qui proclame un souci exigeant de dire la vérité.

On passe de Vénus sortant de l'onde à Nini sortant de son lit ... C'est Delacroix illustrant les frasques du Faust de Goethe, ou montrant les seins triomphants et les aisselles poilues d'une robuste femme du peuple appelée Liberté ; mais c'est aussi le sexe féminin, largement écarté par Courbet et baptisé par lui L'Origine du monde, ou les paysans et le petit peuple de Millet et de Daumier en train de copuler allègrement, voyeurisme réaliste qui culminera avec les scènes de maisons closes de Degas et les ébats des « gentils sauvages » de Gauguin.

Le Romantisme fait revivre la figure du Satan médiéval et descendre le Diable des gargouilles gothiques, tandis que démons et sorcières caracolent impudiques autour du grand bouc noir hérité de Goya. Au grand dam

des bourgeois, des artistes comme Devéria, Le Poitevin, donnent au Malin un caractère lubrique et égrillard qu'il n'avait pas jusque-là. Un Peter Fendi illustre ce retour aux sources païennes, à Pan, aux Cabires, au phallus. Gigantesque, turgescent, herculéen, prêt au combat, le phallus est en effet le véritable héros de ces images destinées à déchaîner un rire franc et joyeux.

Grâce au témoignage d'artistes qui préfèrent rester anonymes plutôt que d'aller en prison, de précieuses illustrations détaillent les vices secrets des nantis et des bourgeois hypocrites. La lithographie en plein essor dénonce au peuple ces clubs privés que fréquente la nouvelle classe dirigeante qui impose le silence sur la sexualité, mais où l'on joue à des petits jeux d'enfants innocents, de «colin-maillard» à «la main chaude», dont on a changé les règles pour les transformer en orgies. On défère aux tribunaux, pour obscénité, des chefs-d'œuvre comme *Madame Bovary* de Flaubert et *Les Fleurs du Mal* de Baudelaire, on envoie Oscar Wilde en prison pour homosexualité, mais on fréquente en secret le club des Flagellants ...

Une *fin de siècle* énervée et maladive, qui s'achemine vers une *Belle Epoque* qui sera plus robuste, donne au Romantisme la forme extrême de la décadence. Une nouvelle race de dandys, d'Aubrey Beardsley à Londres à Félicien Rops à Namur, lutte à son tour contre l'hypocrisie de sa caste en en montrant avec délectation les mœurs dissolues, considérant à juste titre que la sexualité est un élément fondamental de l'existence humaine et constitue en permanence l'un des principaux sujets d'inspiration de l'art. Son arme sophistiquée : rendre le sujet le plus scabreux aussi beau que possible. Evoquer le corps féminin et ses attributs à l'image des mygales vénéneuses nichées au cœur des plus belles fleurs exotiques. Convaincus que la Femme est d'essence diabolique, que c'est le démon qui l'a pourvue du don de tentation – érotique constante du Symbolisme –, ces décadents surenchérissent dans le satanisme, à la manière d'un catalogue freudien avant la lettre, par une satire et une parodie de la sexualité bourgeoise. Huysmans, que Rops illustra, lui rend hommage en ces termes : «Il a peint l'extase démoniaque comme d'autres ont peint les élans mystiques ... en un mot le surnaturel de la perversité, l'au-delà du Mal.»

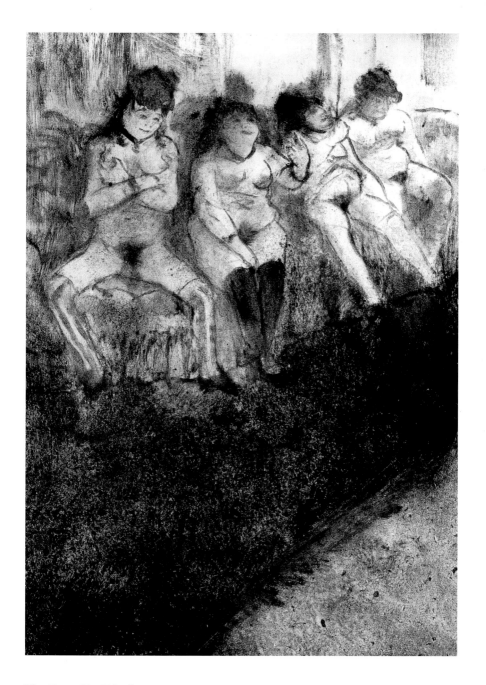

Edgar Degas The Wait, 1879

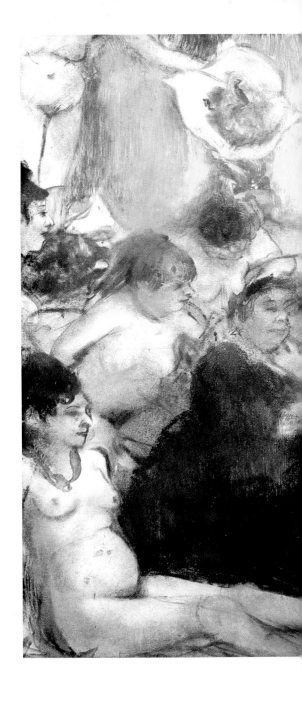

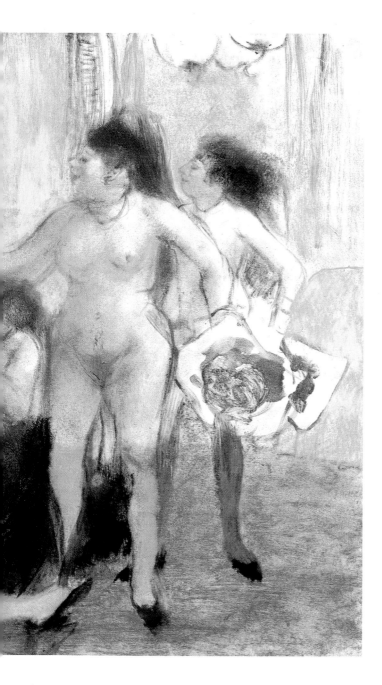

Edgar Degas The Proprietresses's Party, 1878–1879

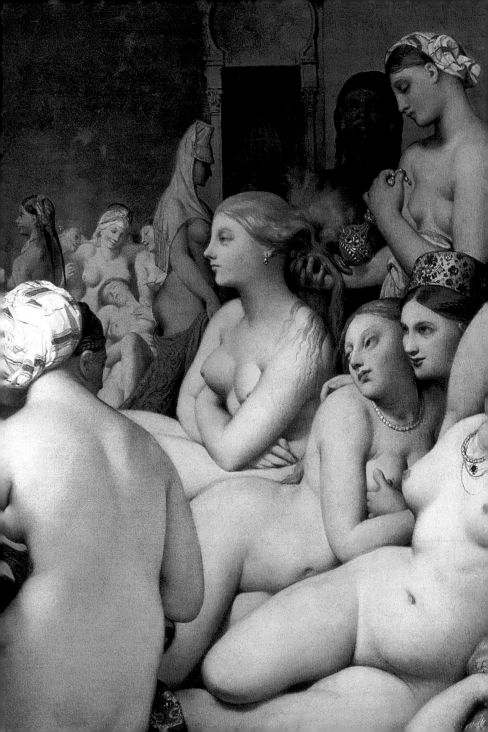

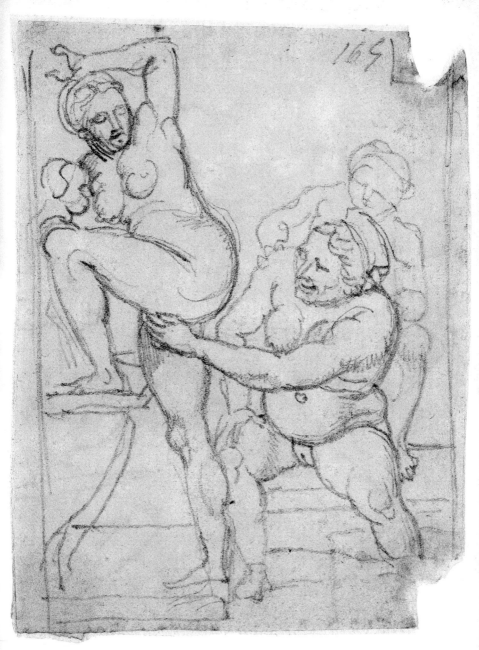

◁ **Ingres** Le Bain turc (detail), 1862; Les Trois femmes au bain (above); this and
the following drawings belong to a sketchbook dated 1800–1806

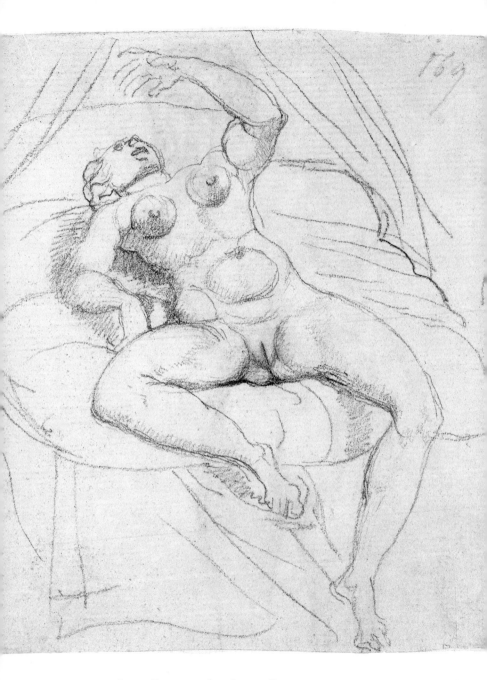

Ingres Femme nue allongée sur un lit

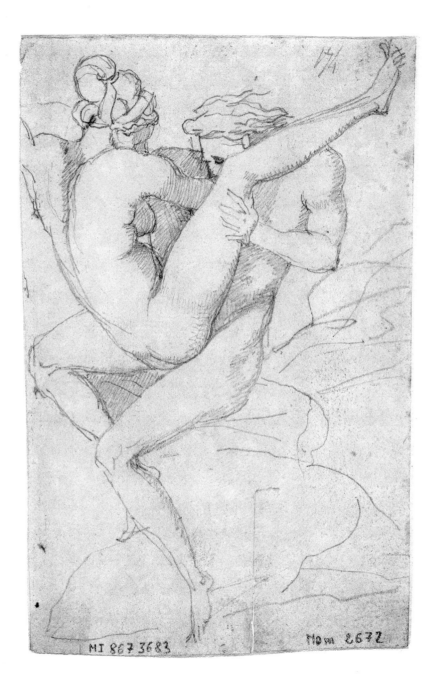

Ingres Couple nu faisant l'amour

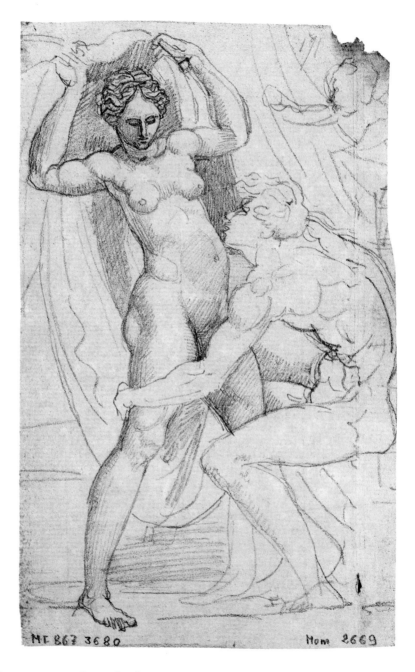

MT 867 3680 Mom 2669

Ingres Couple nu

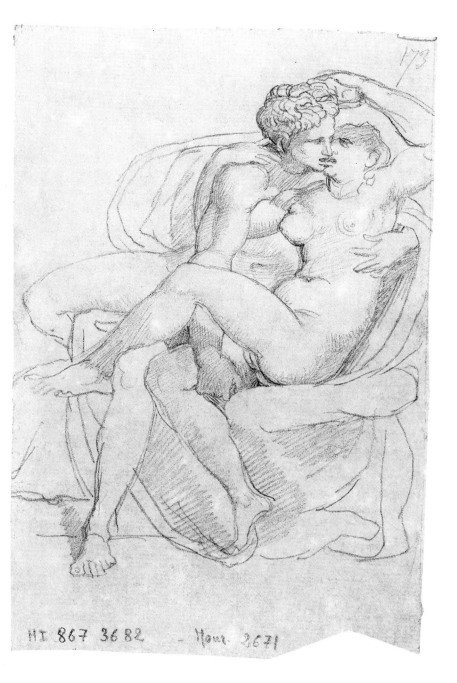

Ingres Mars embrassant Vénus

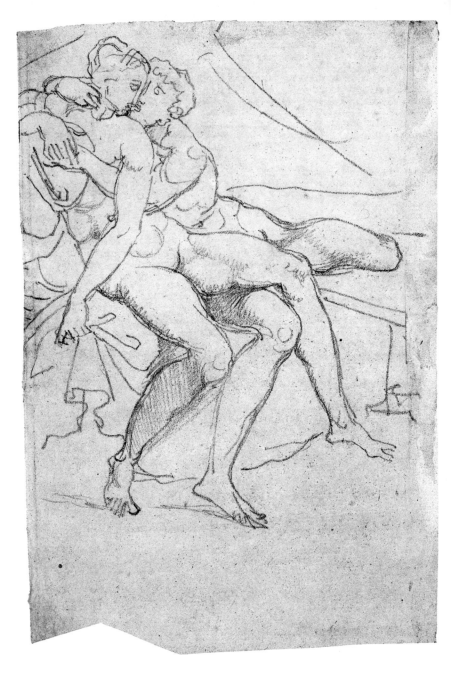

Ingres Couple enlacé sur un lit

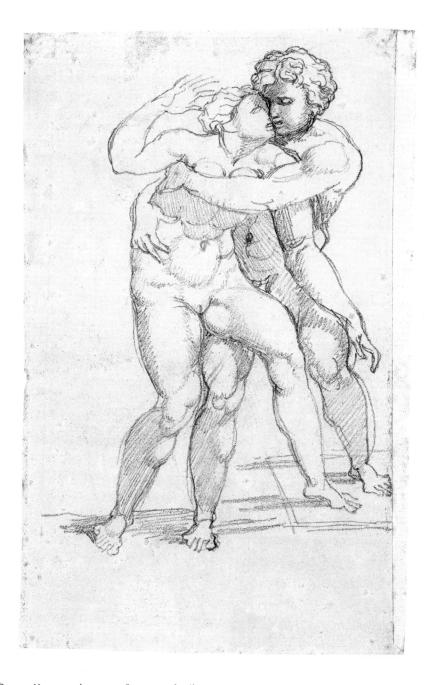

Ingres Homme enlaçant une femme par derrière

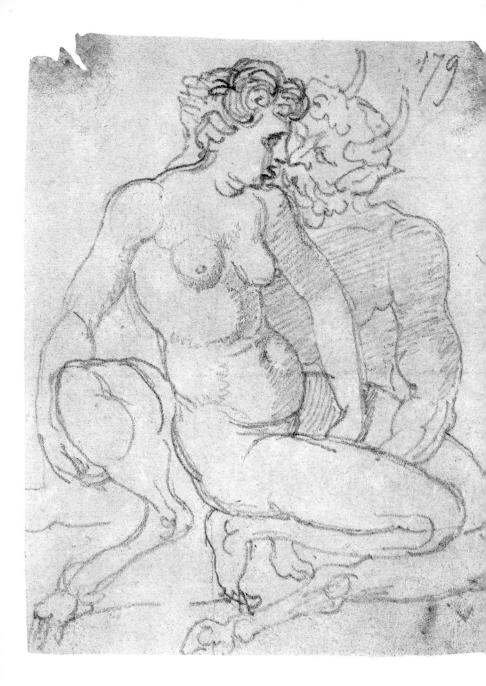

Ingres Femme et satyre

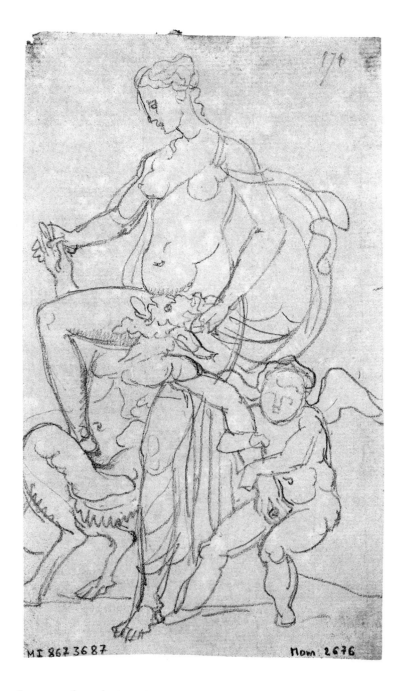

Ingres Femme nue chevauchant un satyre

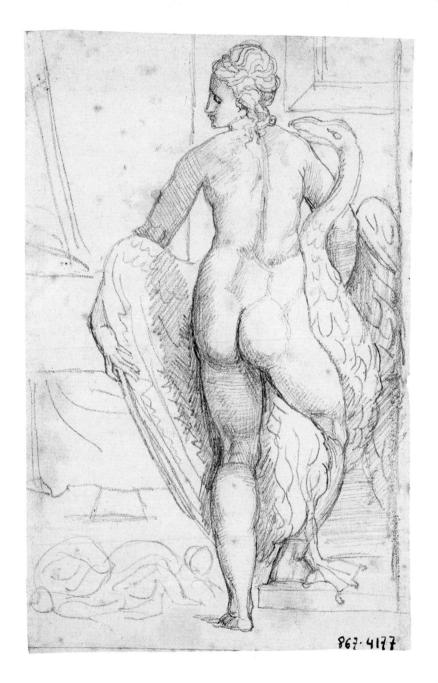

867·4177

Ingres Léda et le cygne

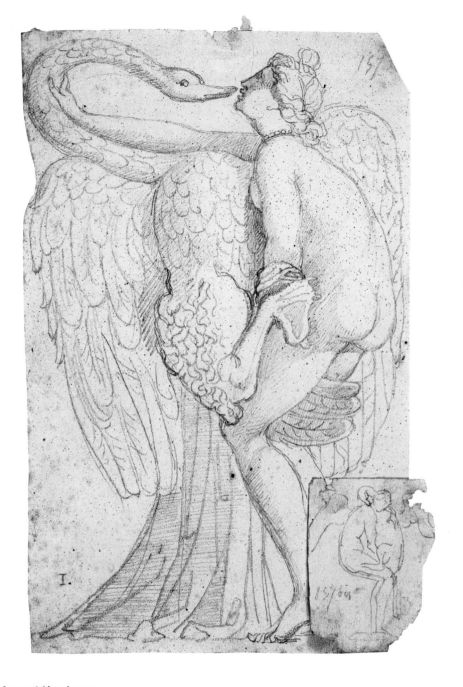

Ingres Léda et le cygne

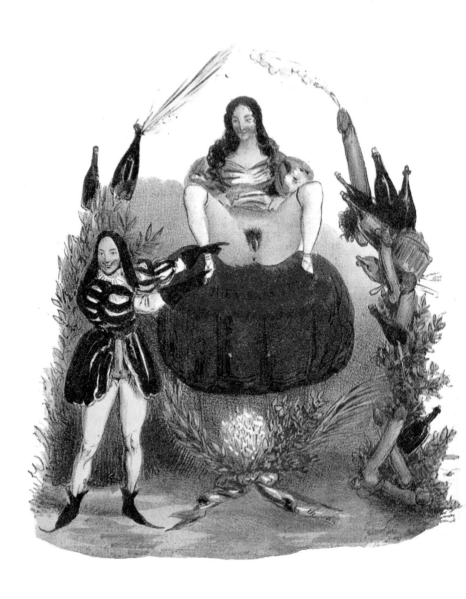

Sequence of anonymous engravings for the *Musée des Familles*,
1840: Without it Nothing

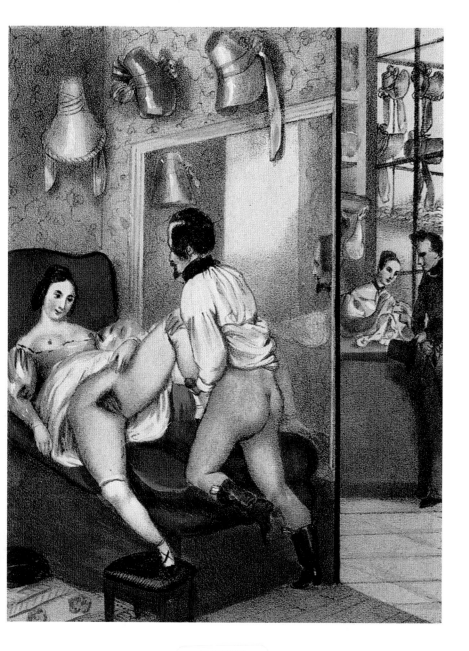

The Fashion Shop

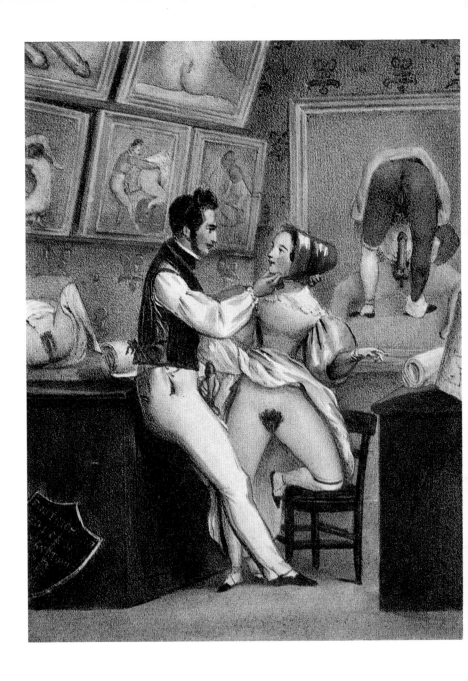

Give Me Some Colouring to Do

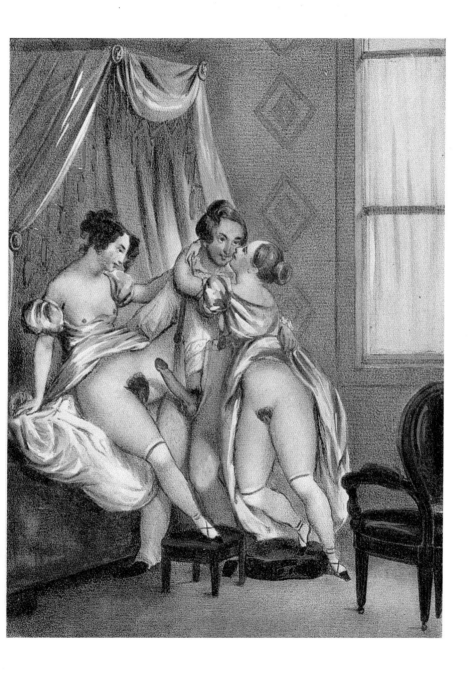

It's My Turn Now

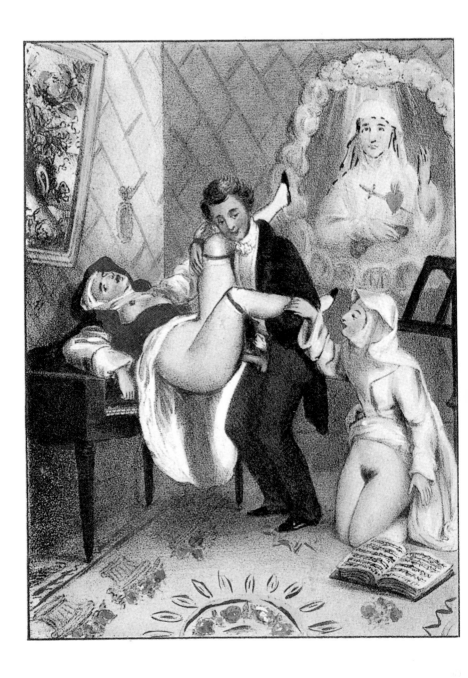

The Music Master

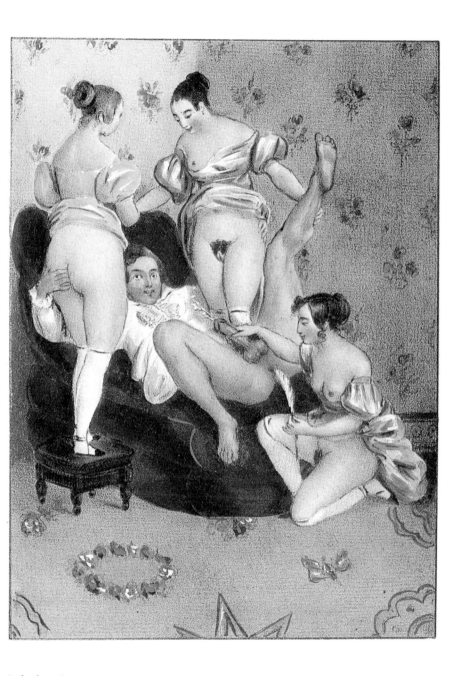

God, what a Come

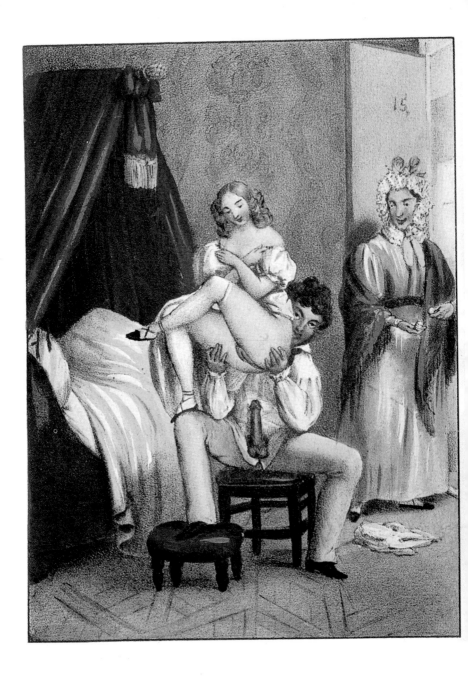

The Good Mother

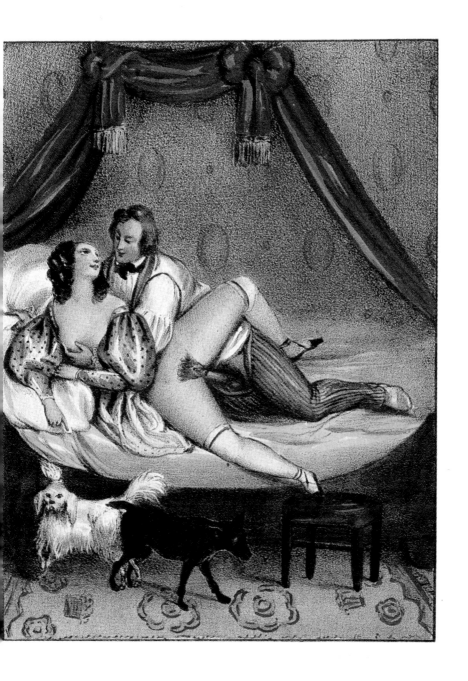

The Good Example

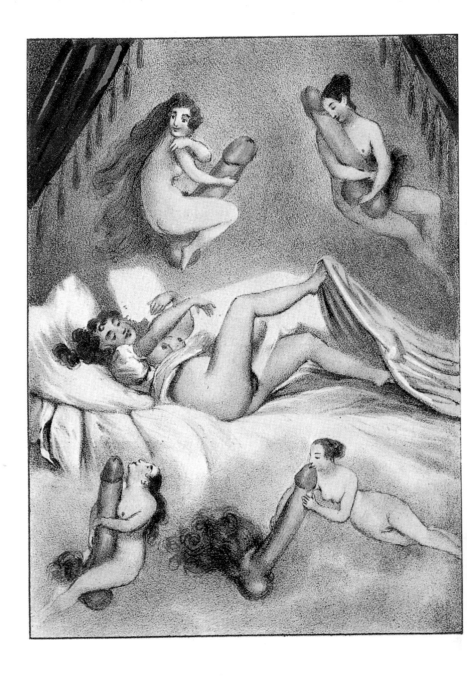

42 · 43 The Virgin's Dream

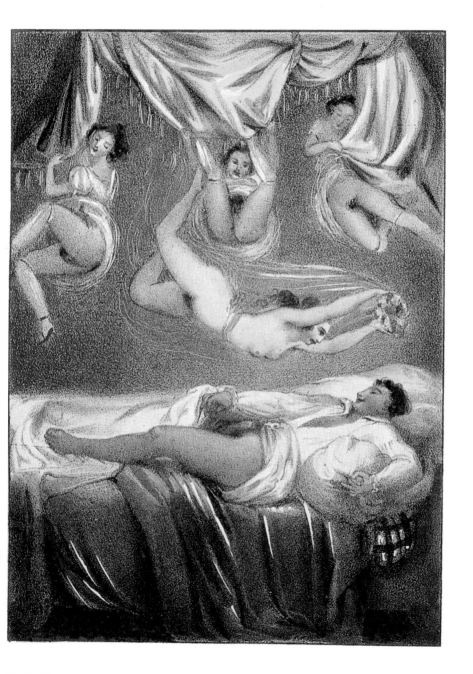

The Wet Dream

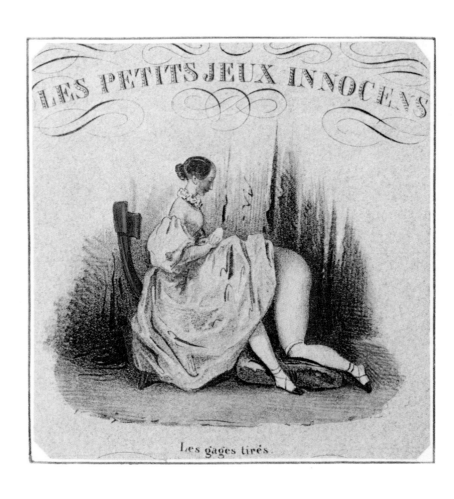

LES PETITS JEUX INNOCENS

Les gages tirés.

Lithographs illustrating forbidden books on children games intended for adults

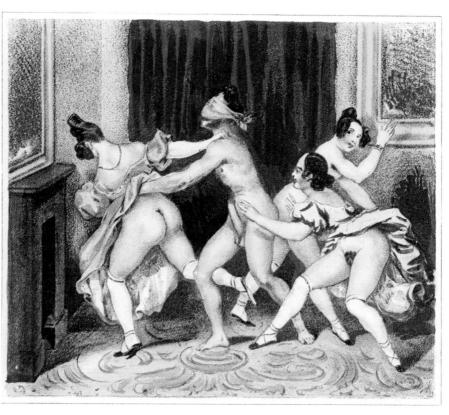

Le Colin-maillard

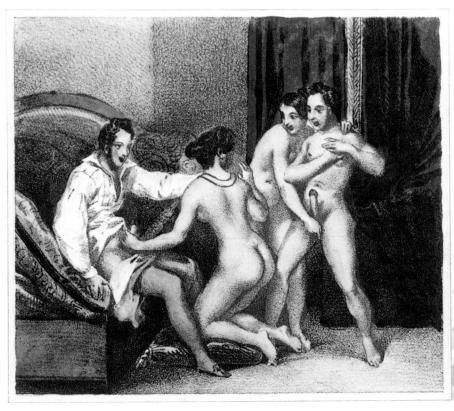

La Main chaude

Lithographs illustrating forbidden books on children games intended for adults

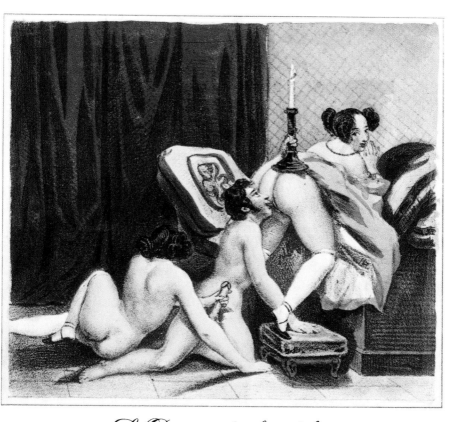

Le Dessous du chandelier

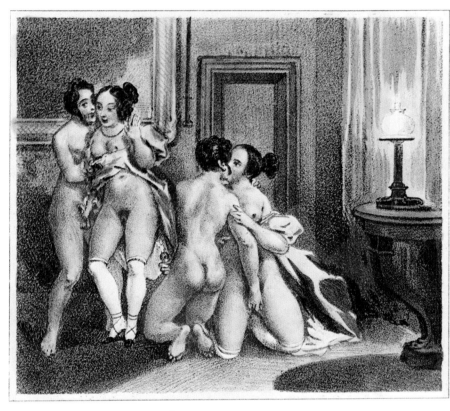

Le Baiser à la capucine

Lithographs illustrating forbidden books on children games intended for adults

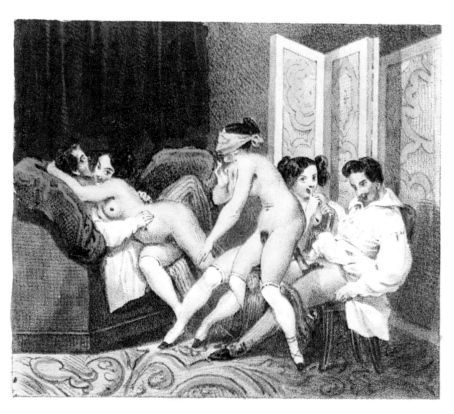

Le Colin-maillard assis

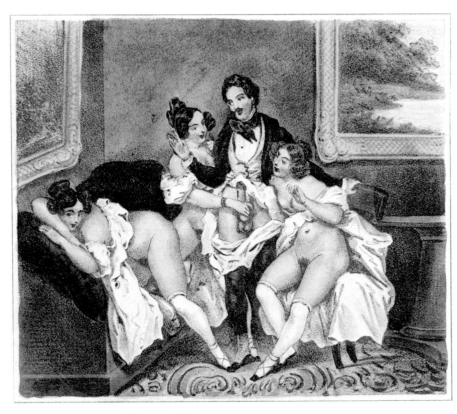

Petit Bonhomme vit encore

Lithographs illustrating forbidden books on children games intended for adults

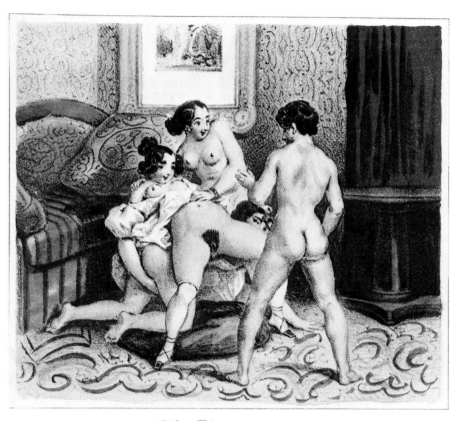

Le Pont d'amour

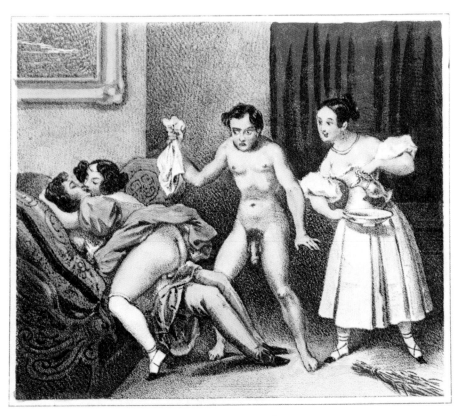

Le Chevalier de la Triste Figure

Lithographs illustrating forbidden books on children games intended for adults

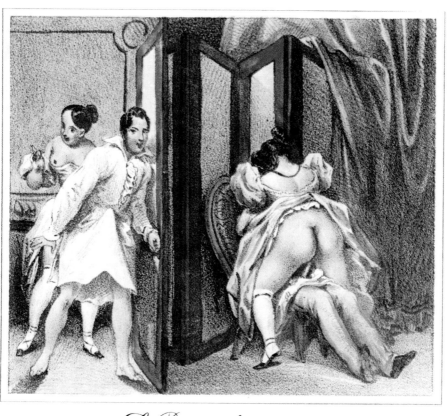

Le Portier du couvent

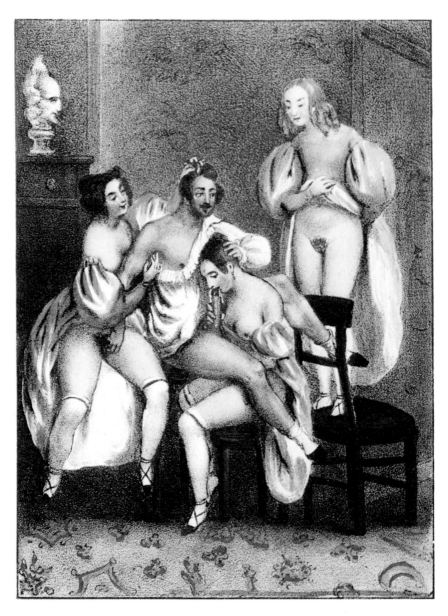

L'asperge à la sauce blanche

Lithographs illustrating forbidden books on children games intended for adults

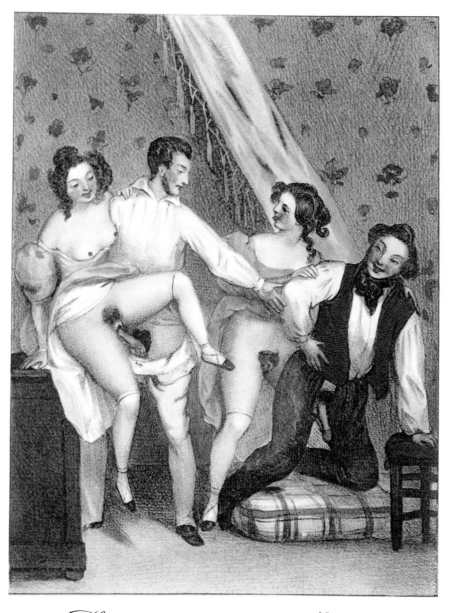

Honneur au courage malheureux

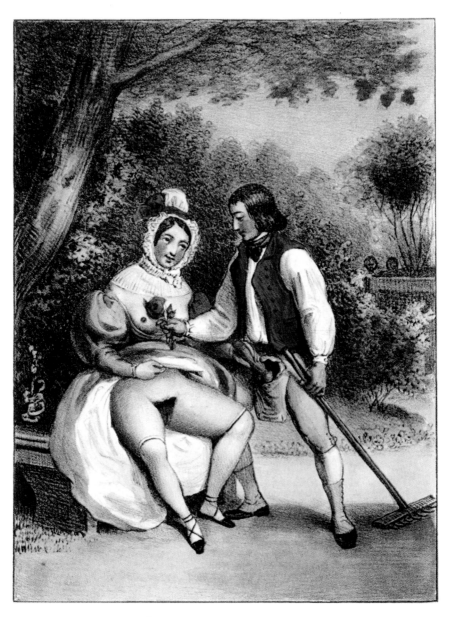

Donne-moi ta rose

Lithographs illustrating forbidden books on children games intended for adults

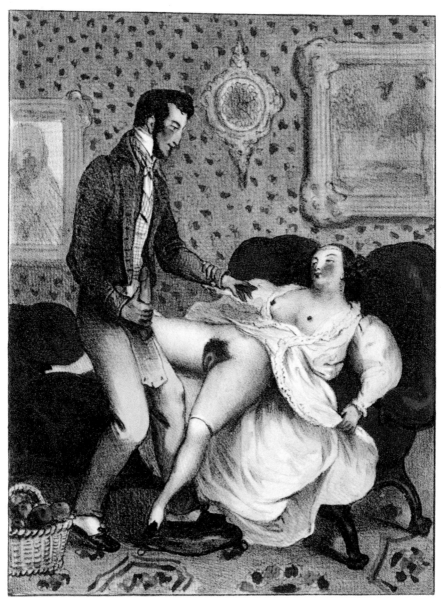

Ne fais donc pas l'enfant

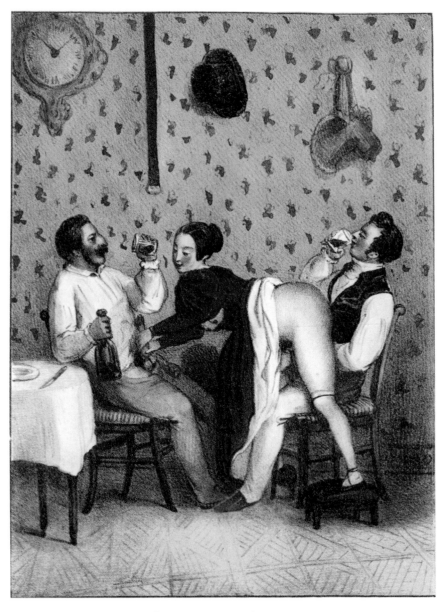

Fillette et bon vin

Lithographs illustrating forbidden books on children games intended for adults

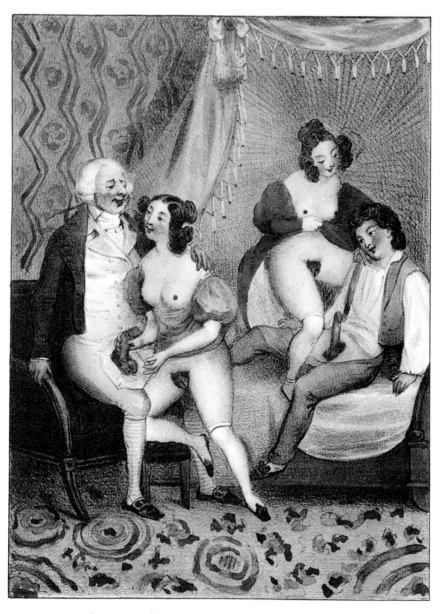

Mon fils a son pucelage, bobonne

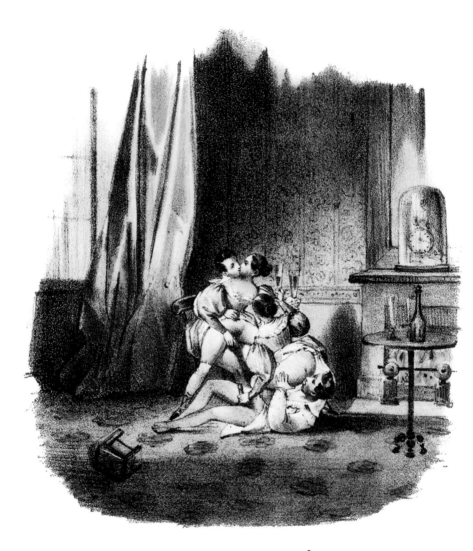

LA PARTIE CARRÉE.

Anonymous Romantic orgies, early 19th century

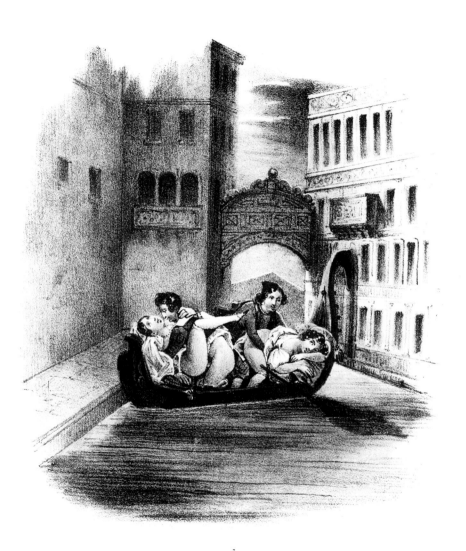

UNE NUIT À VENISE.

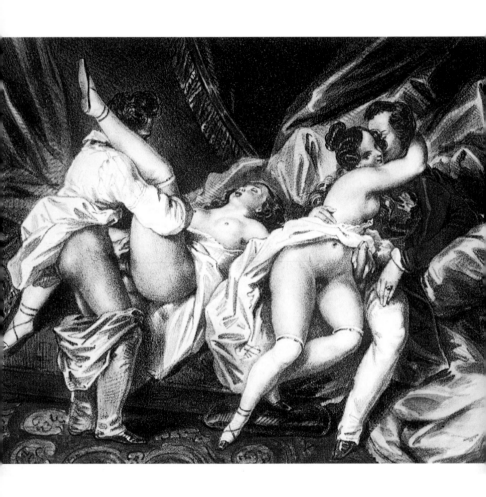

Anonymous Romantic orgies, early 19th century

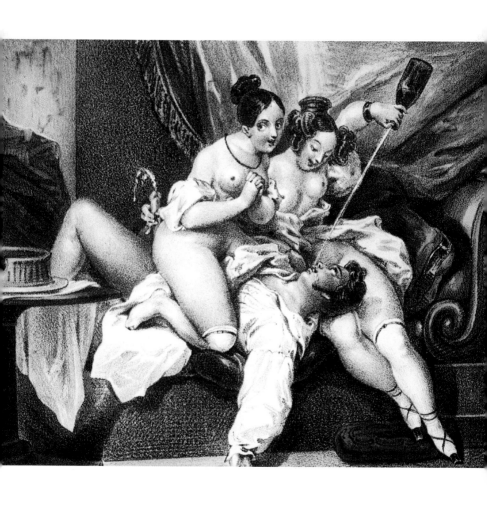

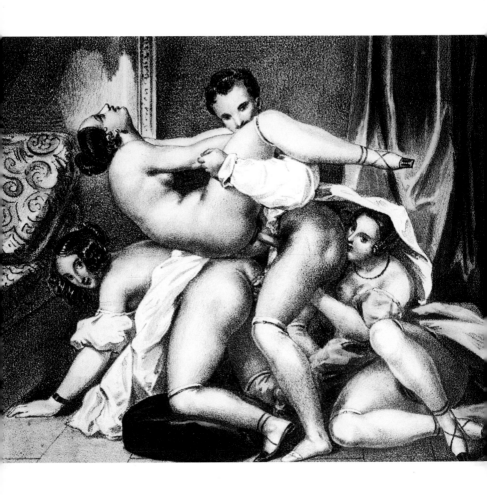

Anonymous Romantic orgies, early 19th century (including pp. 66–67)

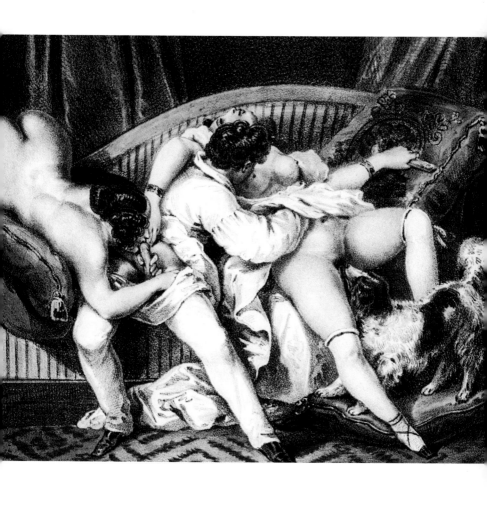

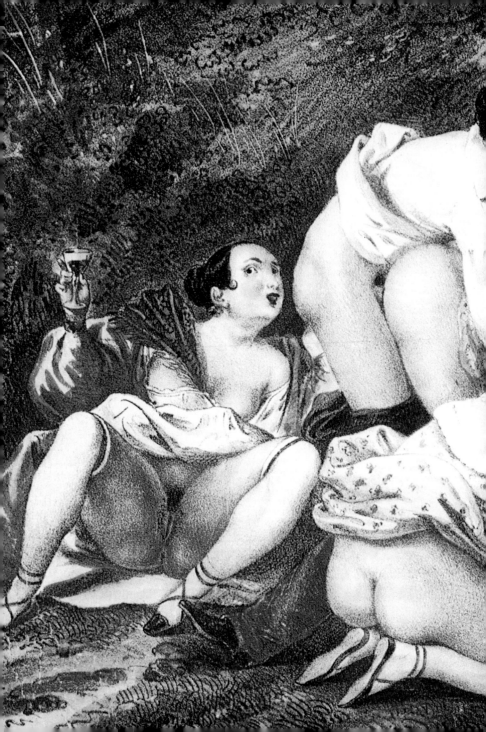

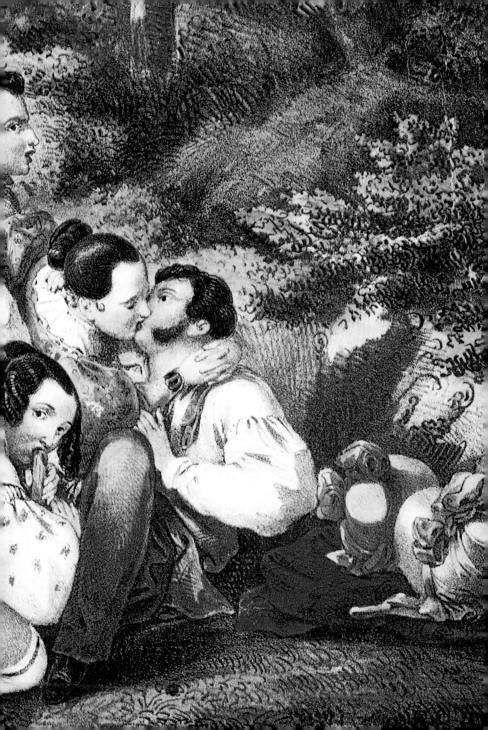

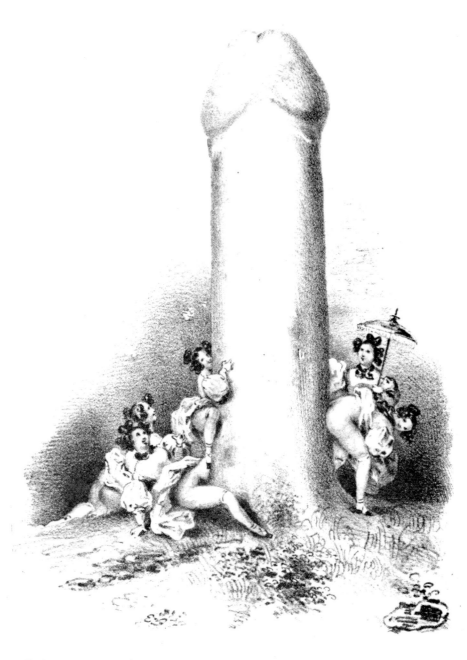

Eugène Le Poitevin from the sequence *Erotic Deviltries*, 1832: The Tree of Life

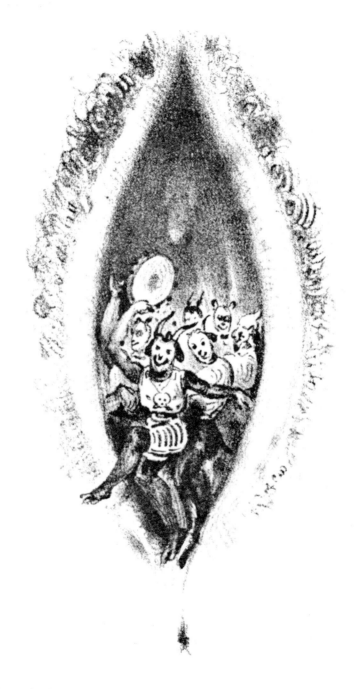

Le Poitevin Good and Evil

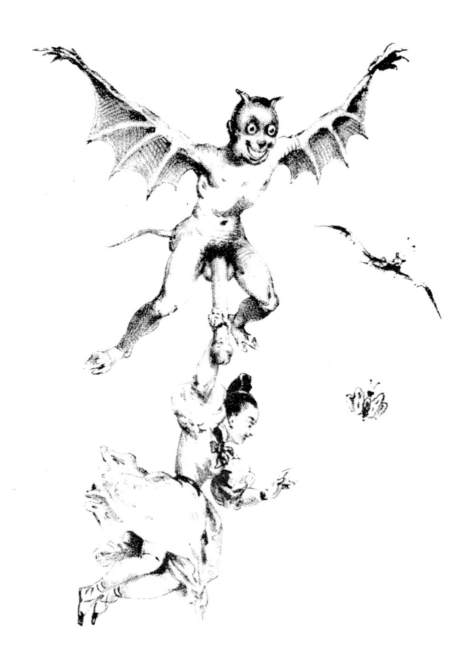

Le Poitevin Pulling the Devil by the Tail

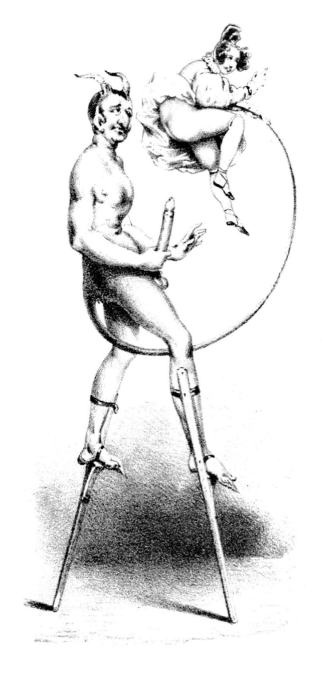

Le Poitevin The New Cup and the Ball, with the New Way of Using It

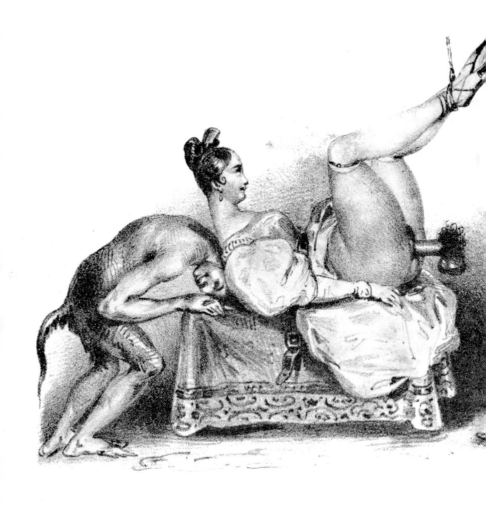

Le Poitevin Deflowering

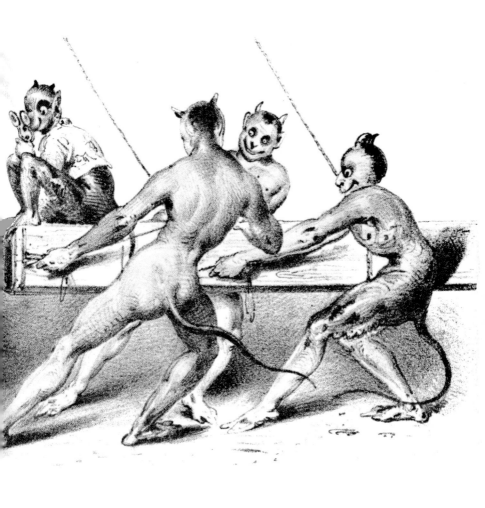

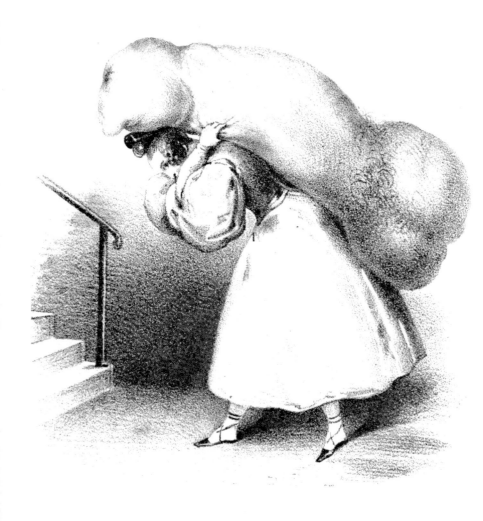

Le Poitevin Living Phenomenon

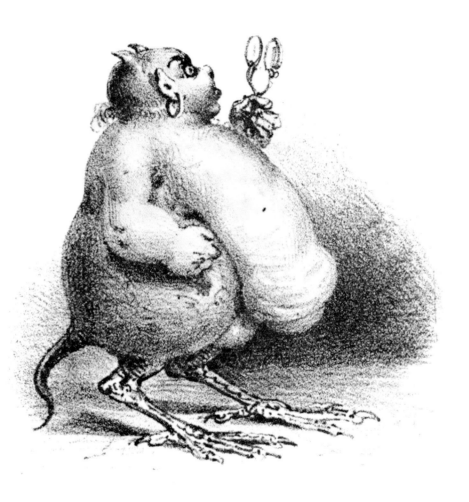

Le Poitevin A Trouvaille

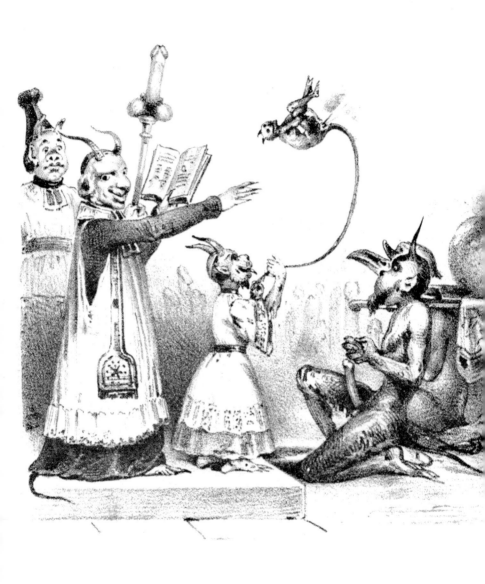

Le Poitevin The Loss of a Member

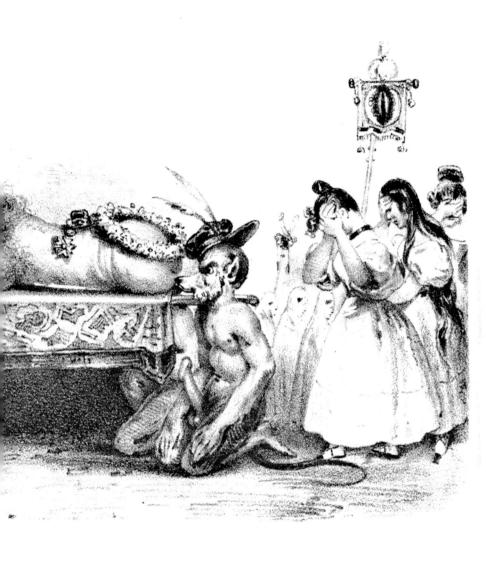

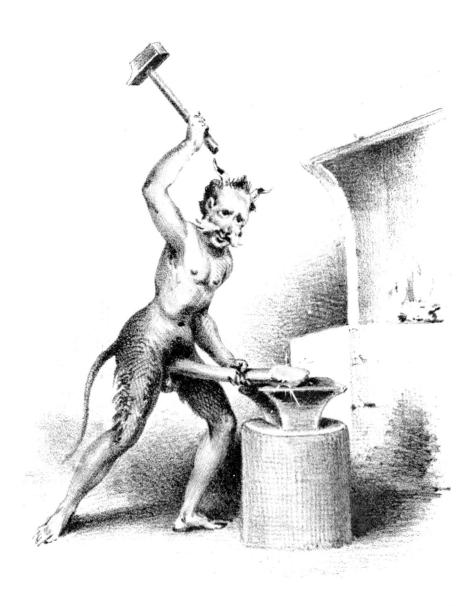

Le Poitevin Bitch of a Prick

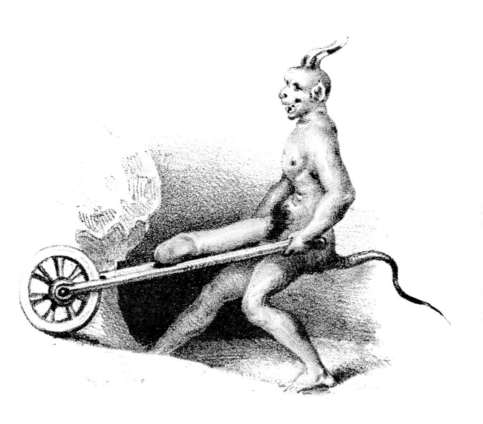

Le Poitevin A Large Affair

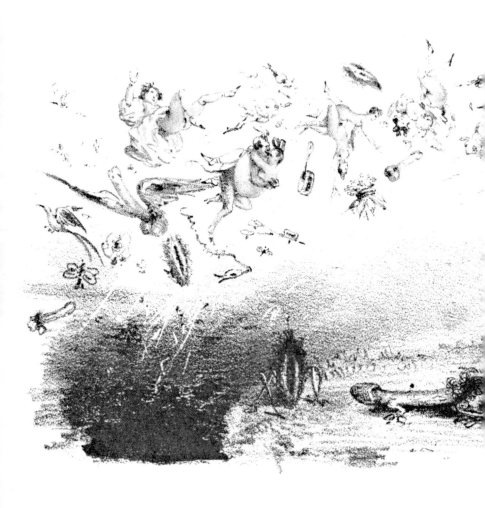

Le Poitevin Diabolic Dew

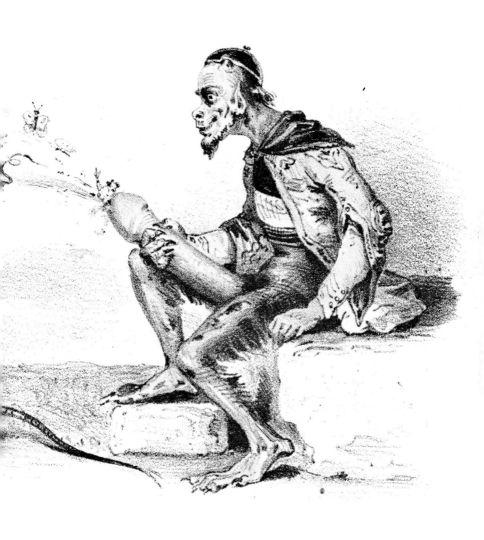

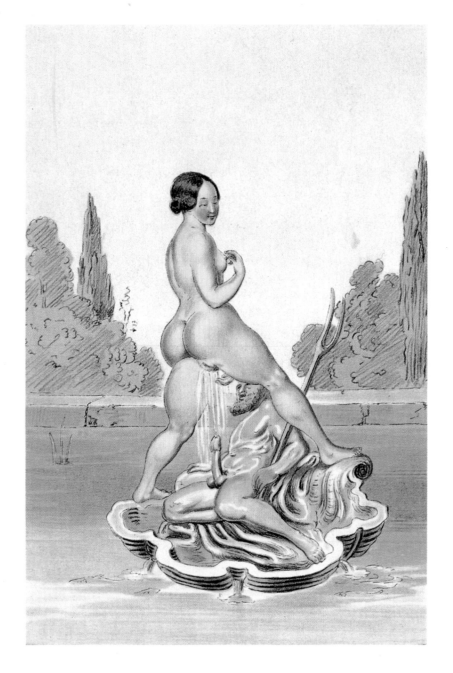

Peter Fendi Sequence of erotic scenes, c. 1835

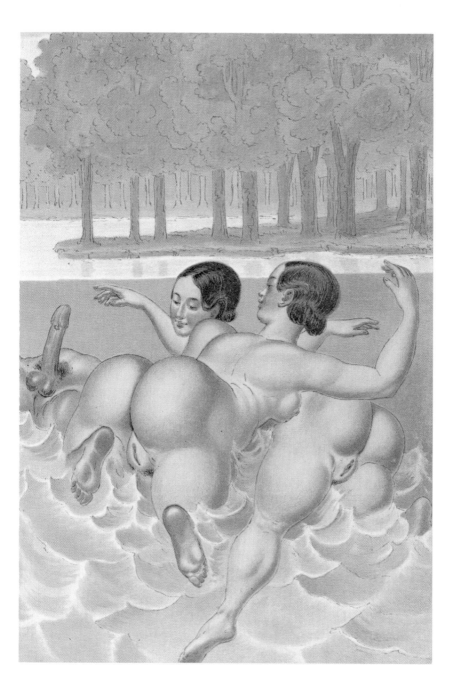

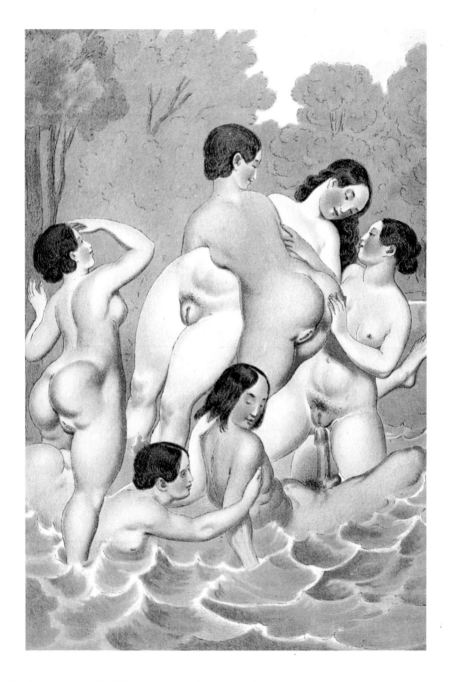

Fendi Sequence of erotic scenes, c. 1835

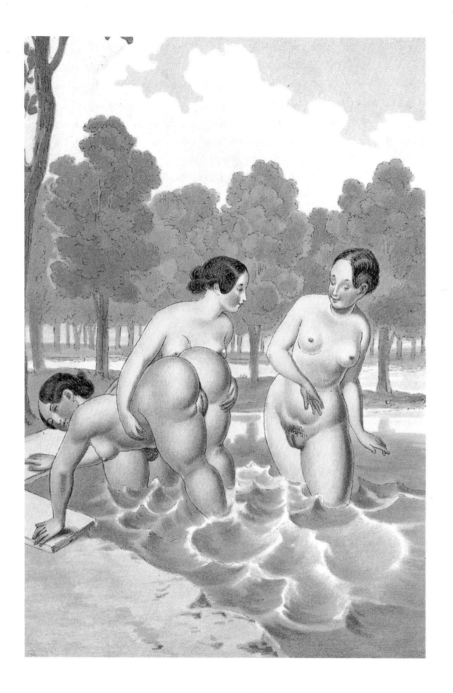

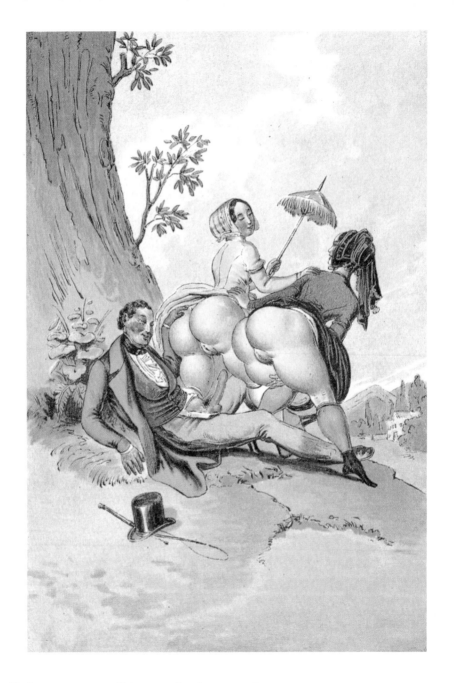

Fendi Sequence of erotic scenes, c. 1835

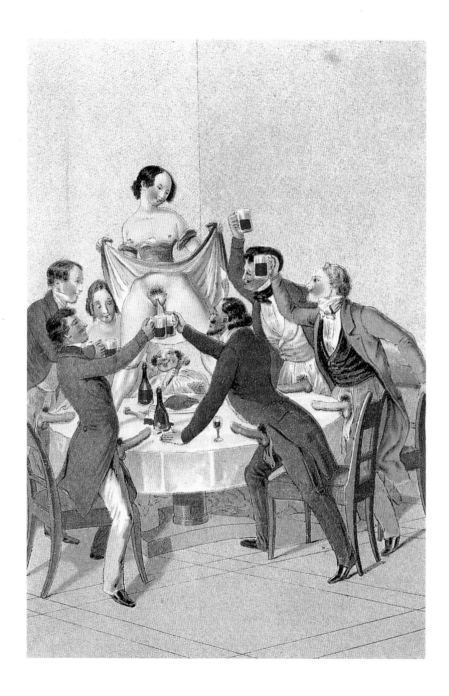

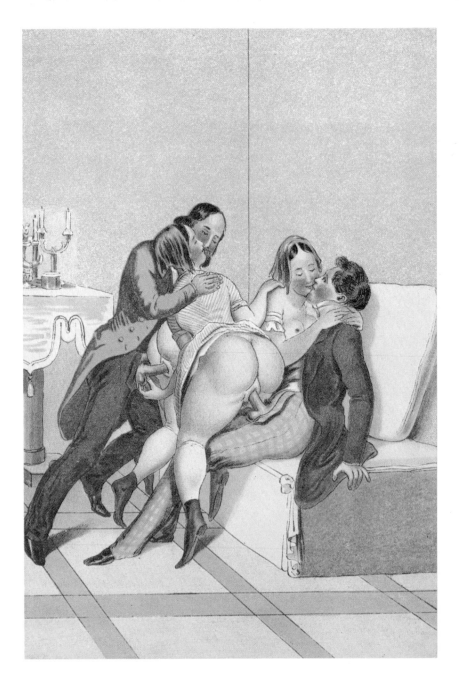

Fendi Sequence of erotic scenes, c. 1835

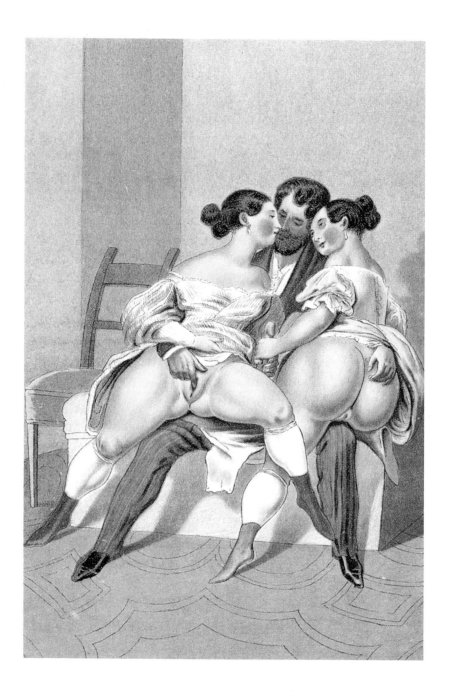

Fendi Sequence of erotic scenes, c. 1835

Fendi Sequence of erotic scenes, c. 1835

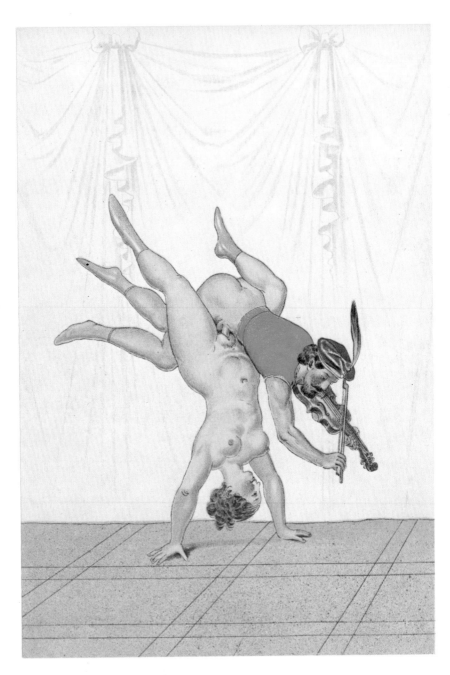

Fendi Sequence of erotic scenes, c. 1835

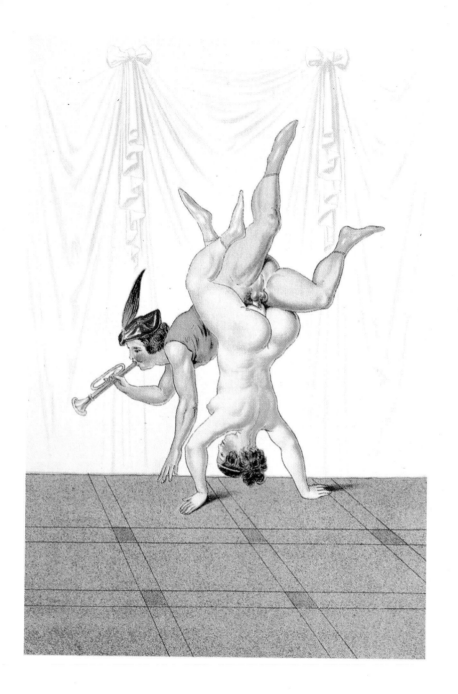

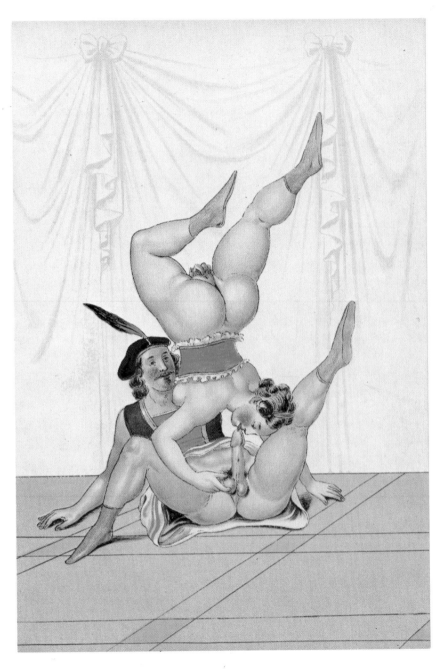

Fendi Sequence of erotic scenes, c. 1835

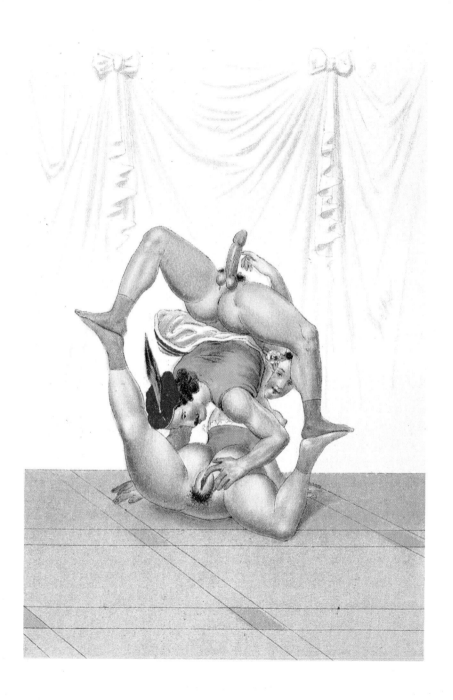

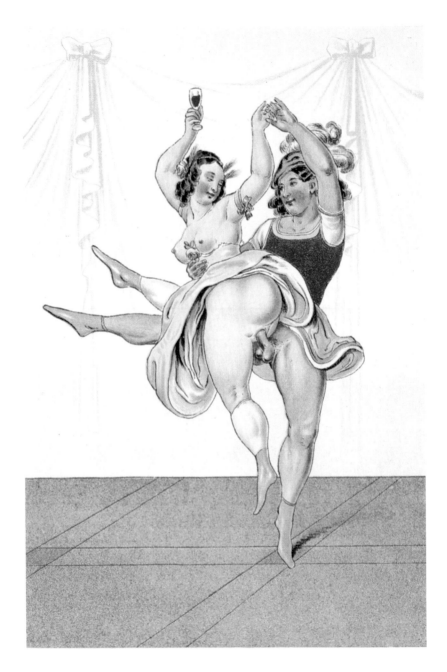

Fendi Sequence of erotic scenes, c. 1835

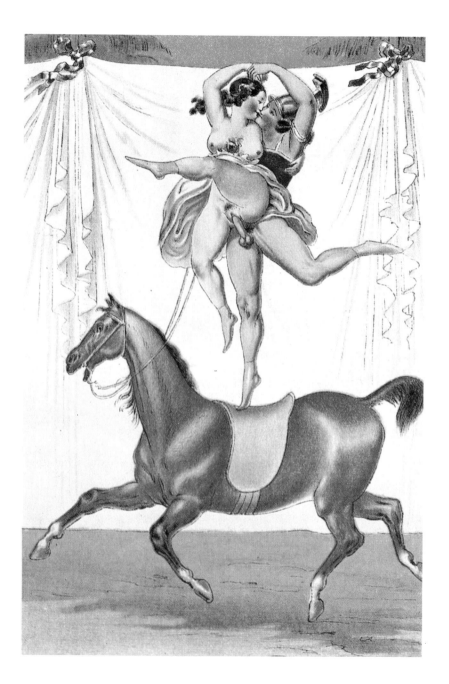

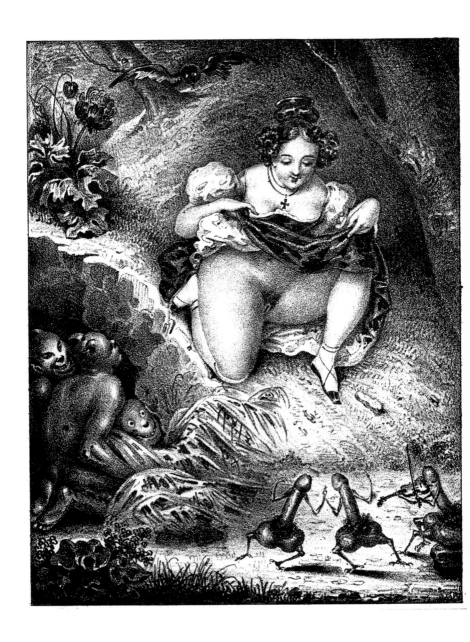

Achille Devéria Diabolico Foutro Manie; sequence of lithographs on the history of
morals under Louis-Philippe, c. 1835

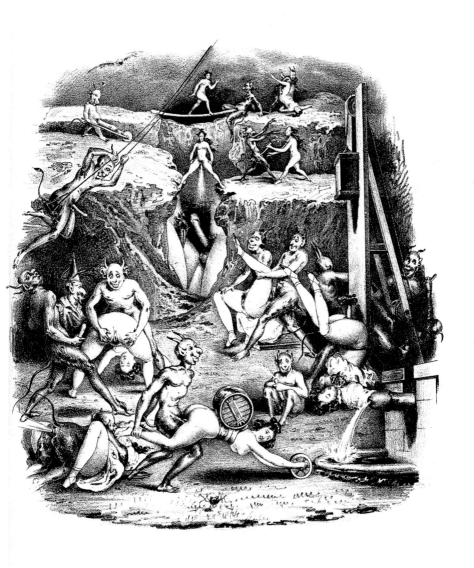

Devéria Diabolico Foutro Manie, c. 1835

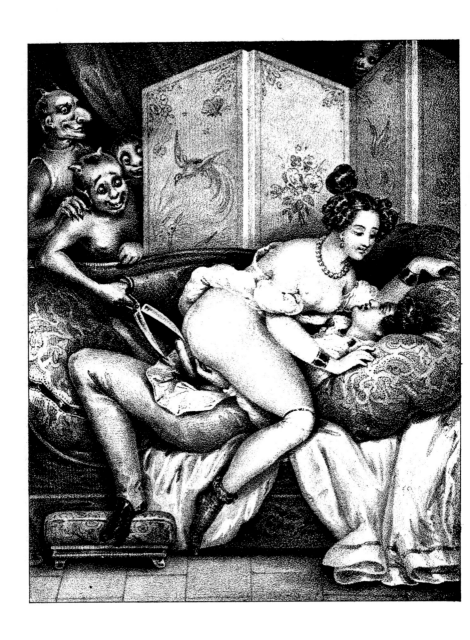

Devéria Diabolico Foutro Manie, c. 1835

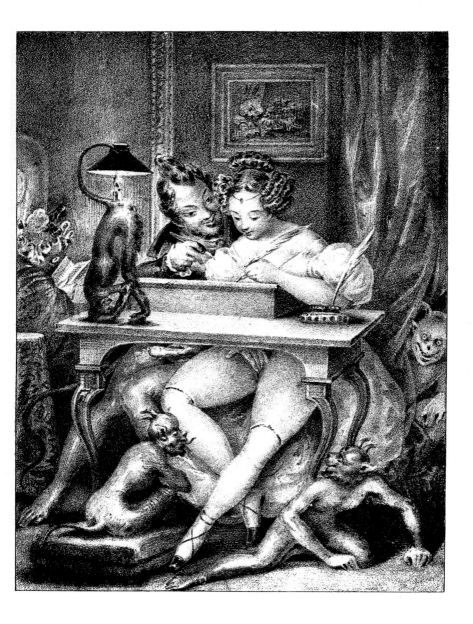

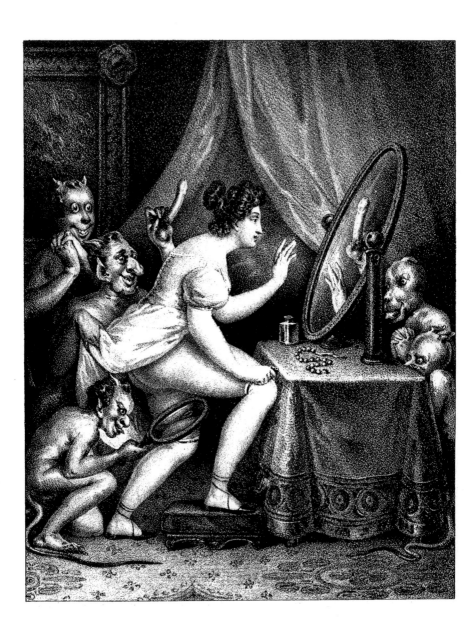

Devéria Diabolico Foutro Manie, c. 1835

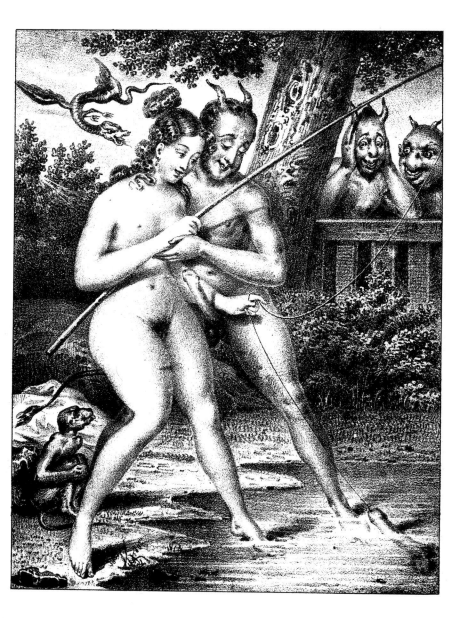

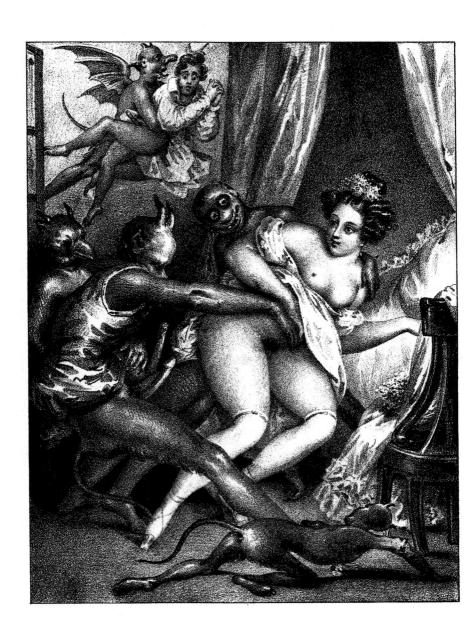

Devéria Diabolico Foutro Manie, c. 1835

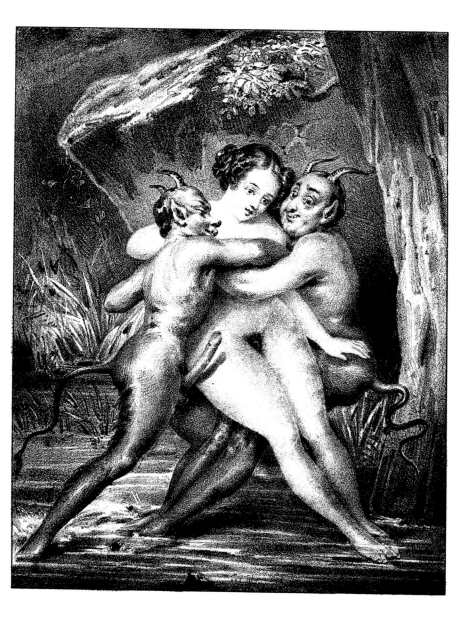

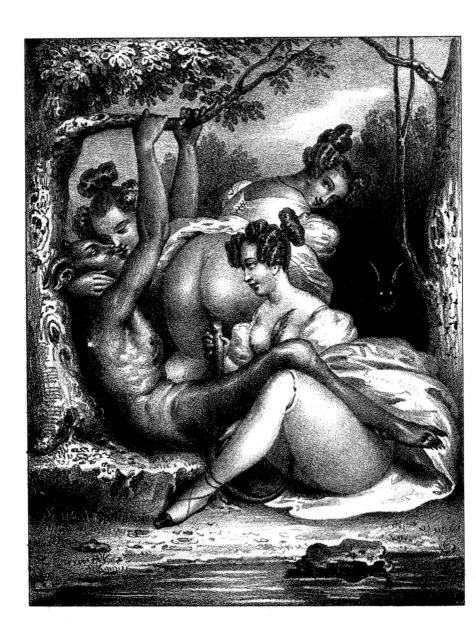

Devéria Diabolico Foutro Manie, c. 1835

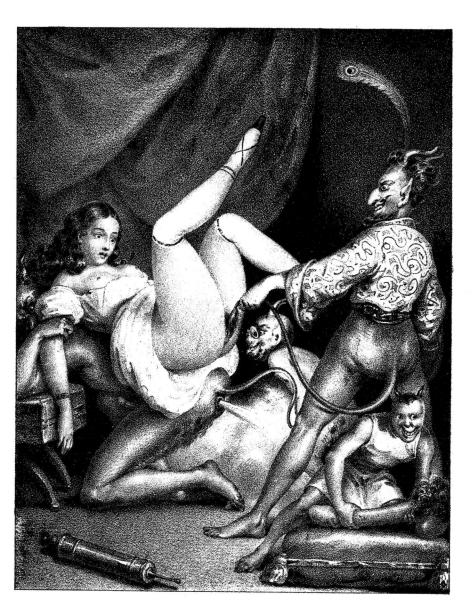

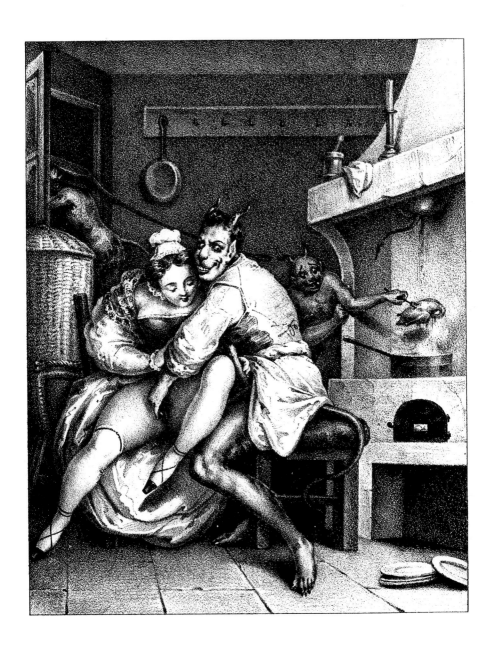

Devéria Diabolico Foutro Manie, c. 1835

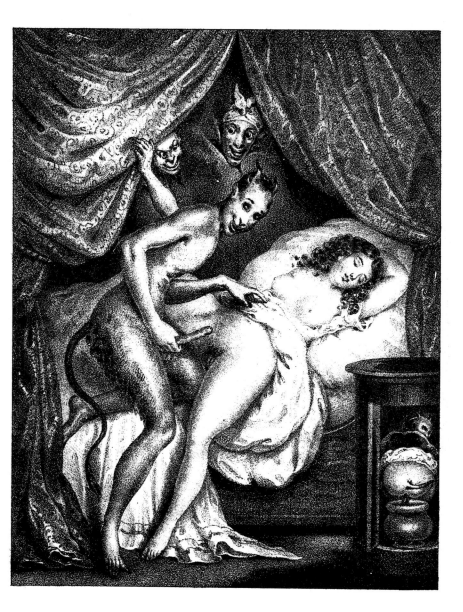

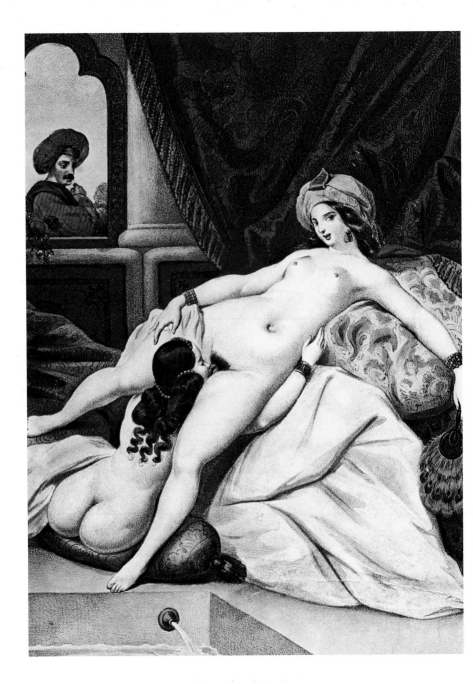

Devéria Illustration for *Les Mille et une nuits*, c. 1850

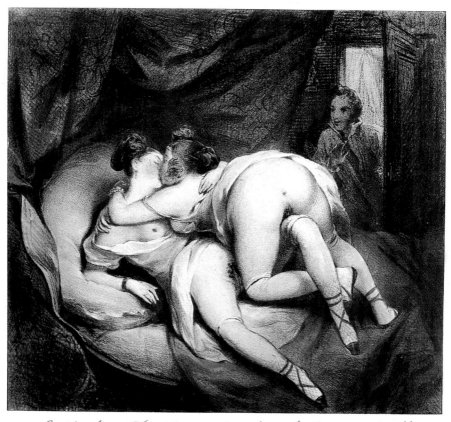

Épuisée, abattue, Fanny laissa tomber ses bras; pâle, elle restait insensible comme une belle morte. la Comtesse délirait, le plaisir la tuait et ne l'achevait pas.

Sequence of lithographs attributed to **Achille Devéria** for the obscene novel
by Alfred de Musset: *Gamiani or A Night of Excess*, c. 1848

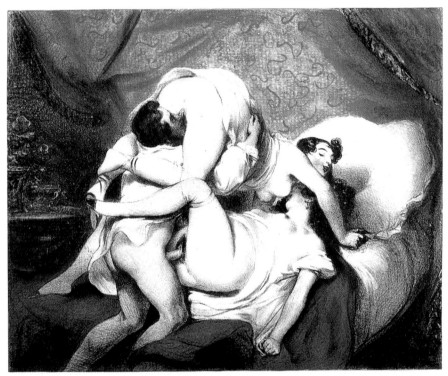

Sans rien perdre de ma position, je parvins à saisir fortement les cuisses de la Comtesse, et les tenant élevées au dessus de ma tête, je portai à loisir une langue active et dévorante sur sa partie en feu.

Sequence of lithographs attributed to **Achille Devéria** for the obscene novel by Alfred de Musset: *Gamiani or A Night of Excess*, c. 1848

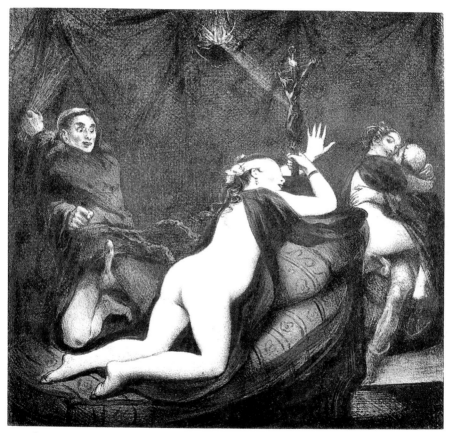

A travers le bruit de mes coups, j'entendais confusement des cris, des éclats, des mains frappant sur des chairs, c'étaient aussi des rires insensés, rires nerveux, convulsifs, précurseurs de la joie des sens.

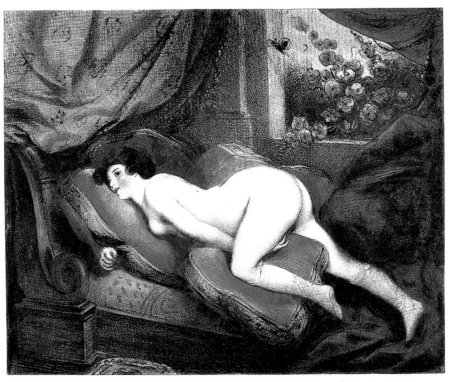

Je m'arrête je frémis, il me semble que je fonds que je m'abîme, ah! m'écriai je mon dieu ah! ah! et je me relevai subitement épouvantée, j'étais toute mouillée.

Sequence of lithographs attributed to **Achille Devéria** for the obscene novel by Alfred de Musset: *Gamiani or A Night of Excess*, c. 1848

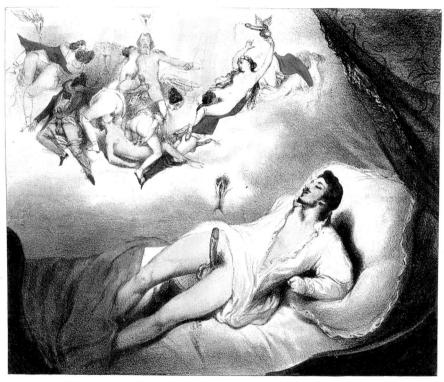

Mes souvenirs classiques se mêlant un instant à mes rêves, je vis Jupiter en feu,
Junon maniant sa foudre, je vis tout l'Olympe en rut dans un désordre, un pêle-mêle
étranges.

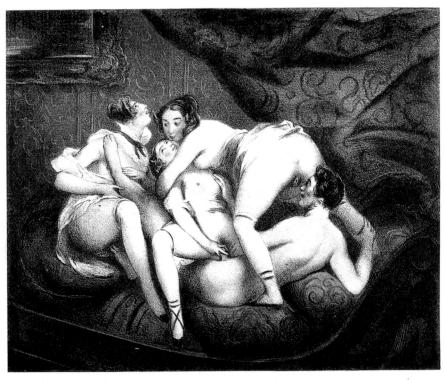

Et voilà que chacun se meut, s'agite, s'excite au plaisir; je dévore des yeux cette scène animée, m.s deux mains battent une gorge brûlante ou se portent frénétiques sur des charmes plus secrets encore.

Sequence of lithographs attributed to **Achille Devéria** for the obscene novel
by Alfred de Musset: *Gamiani or A Night of Excess*, c. 1848

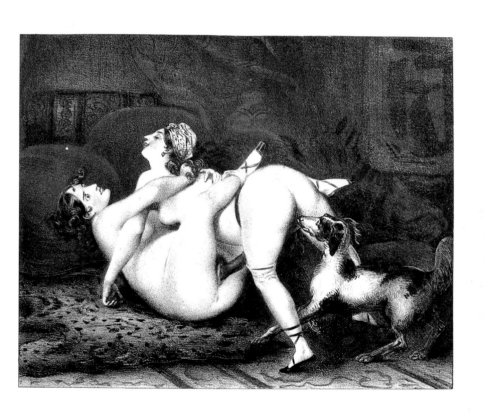

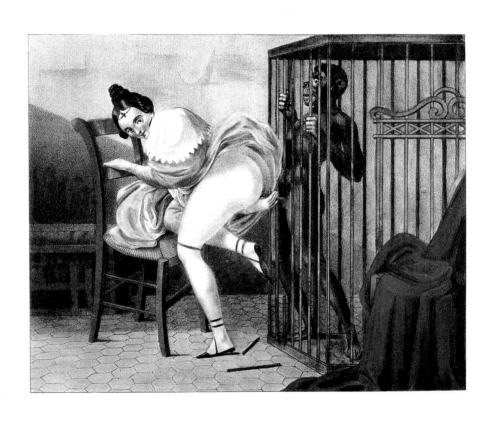

Sequence of lithographs attributed to **Achille Devéria** for the obscene novel
by Alfred de Musset: *Gamiani or A Night of Excess*, c. 1848

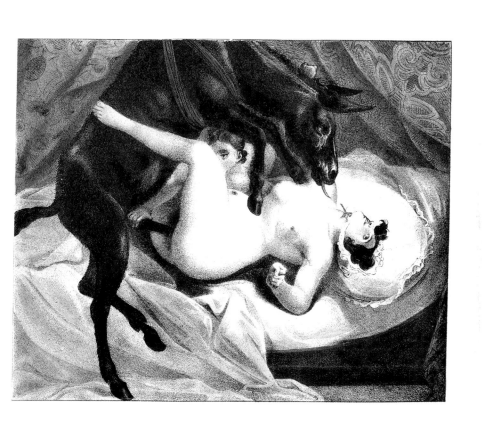

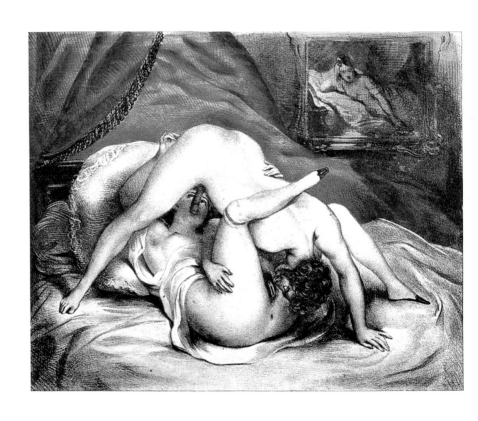

Sequence of lithographs attributed to **Achille Devéria** for the obscene novel by Alfred de Musset: *Gamiani or A Night of Excess*, c. 1848

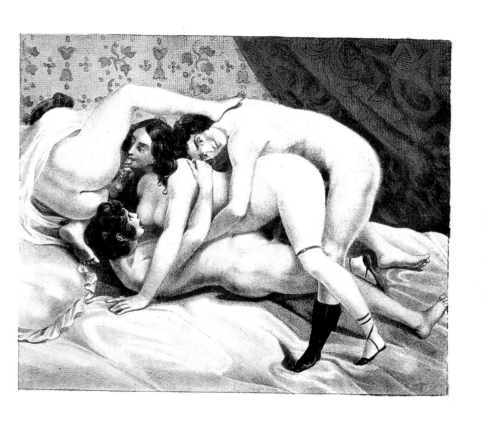

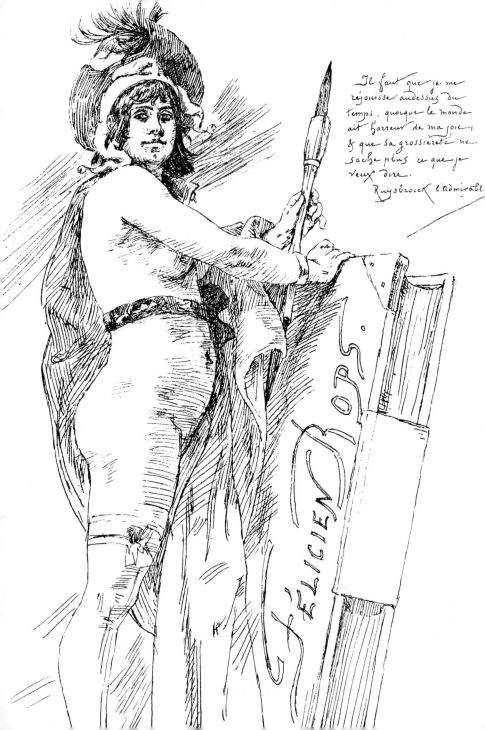

Il faut que je me
réjouisse audessus du
temps, quoique le monde
ait horreur de ma joie,
& que sa grossiereté ne
sache plus ce que je
veux dire.
Ruysbroeck l'admirable

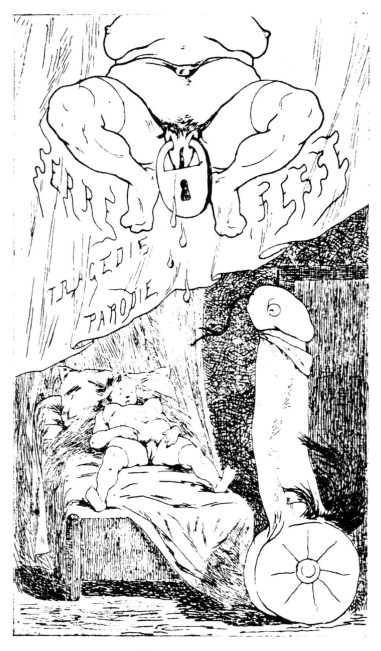

◁ **Félicien Rops** La Muse de Rops

Illustration for the tragicomedy
Serre Fesse, 1878

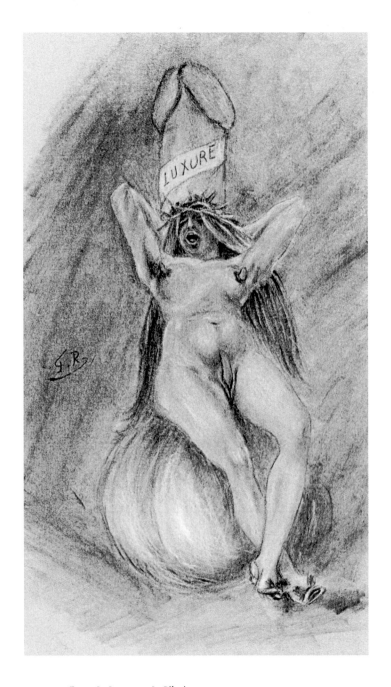

Rops La Luxere ou Le Pilori

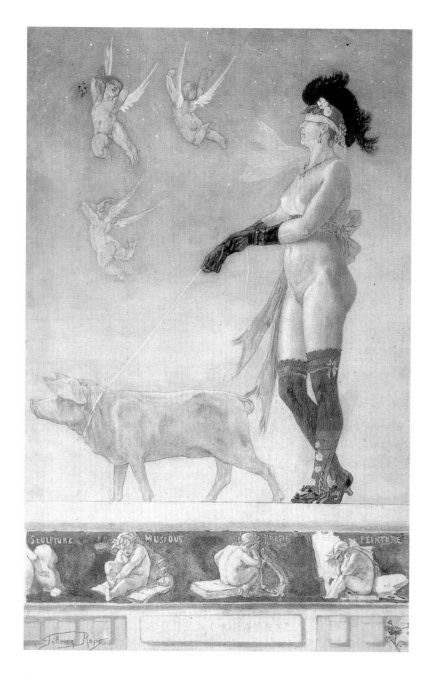

Rops Pornokrates, 1878

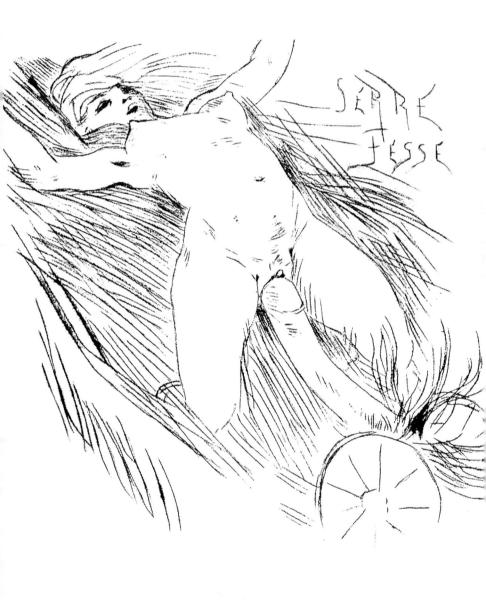

Rops Illustration for *Serre Fesse*, 1878 ▷ Le Vélocipède

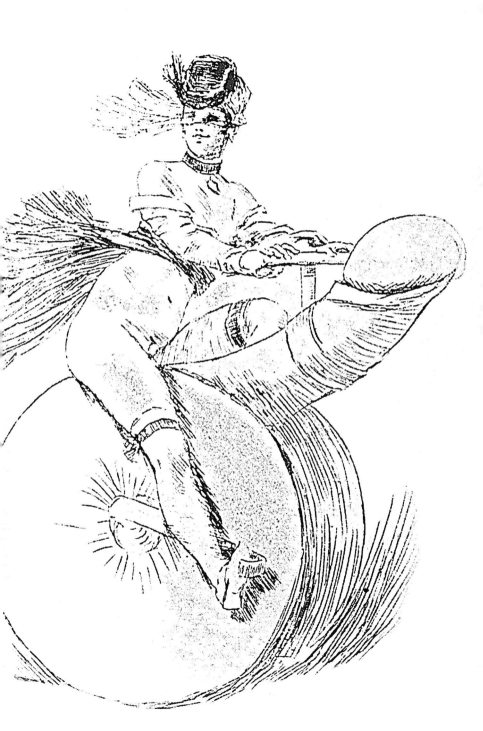

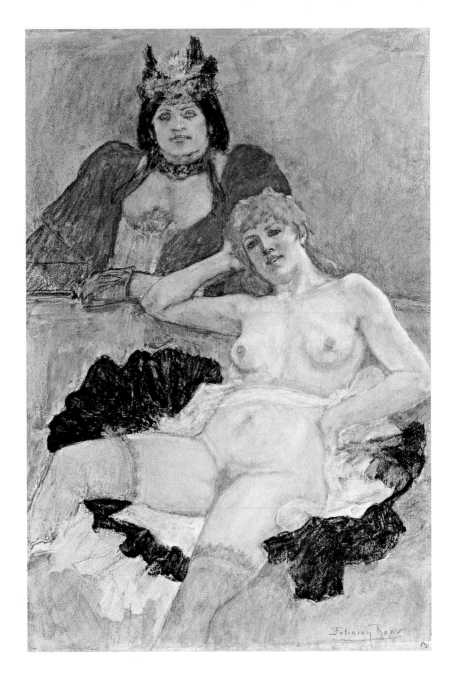

Rops Les Deux Amies, c. 1880

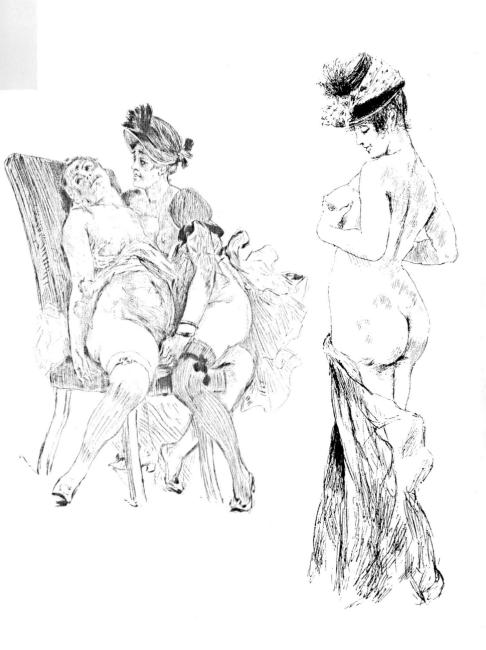

Rops En visite (left); Suffisance (right)

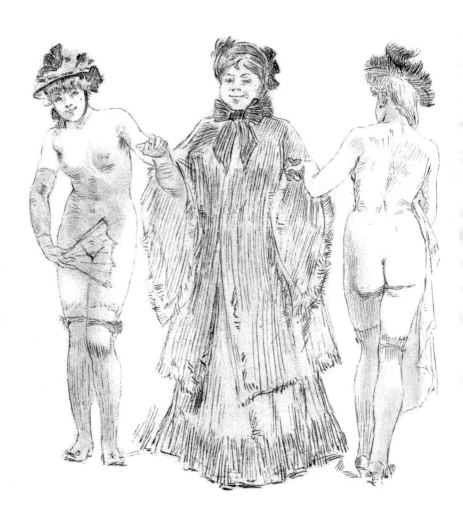

Rops Les Cousines de la colonelle

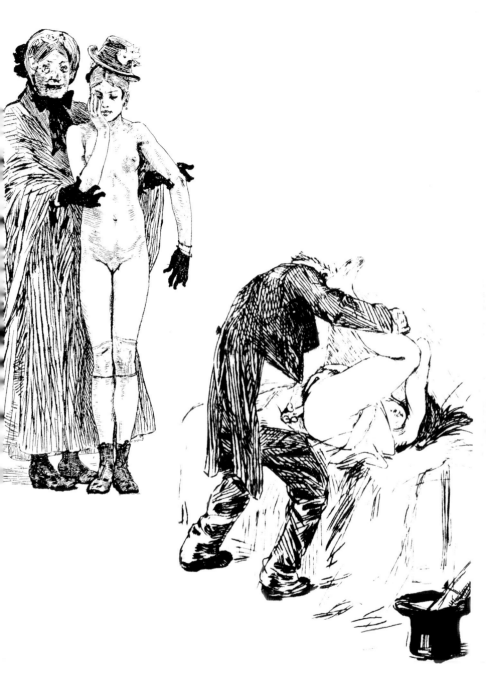

Rops Ma fille, monsieur Cabanel! (left); Abus de confiance (right)

Rops Impudence, c. 1878

Rops Un groom pour tout faire

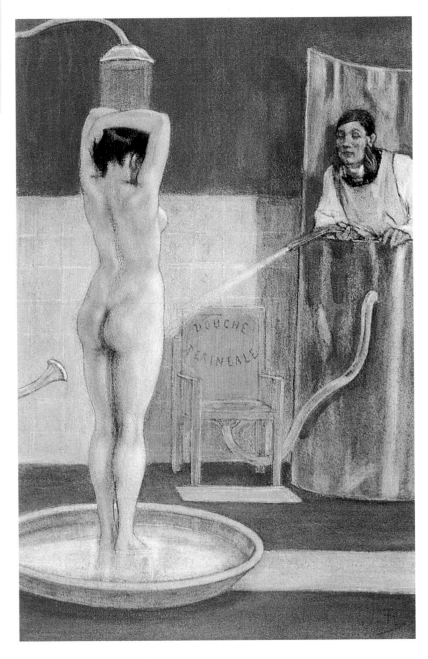

Rops La Douche ou Douche périnale, illustration for the album
Cent légers croquis sans prétention pour réjouir les honnêtes gens, 1878

Rops Le joyeux bidet

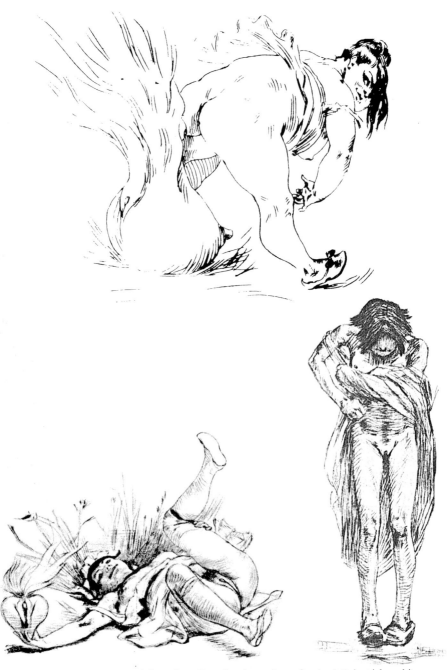

Rops Darwinique n°2 ou Transformisme n°2, c. 1870 (top); Puberté de vachère, c. 1878–1890 (bottom right); La cœur sur la main (bottom left)

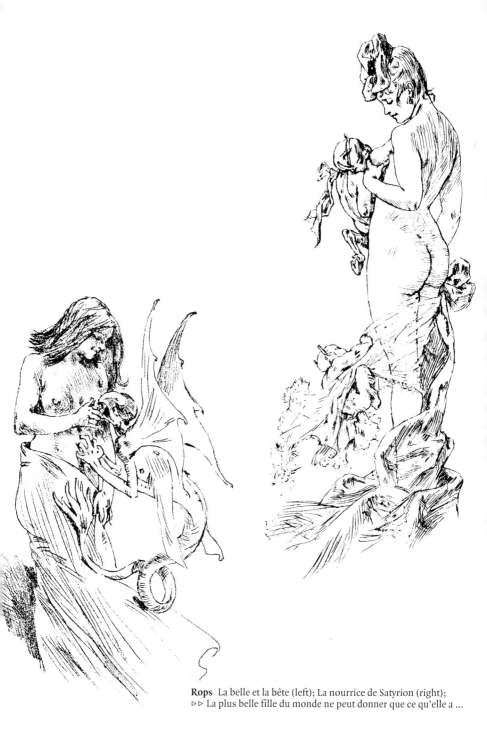

Rops La belle et la bête (left); La nourrice de Satyrion (right);
▷▷ La plus belle fille du monde ne peut donner que ce qu'elle a ...

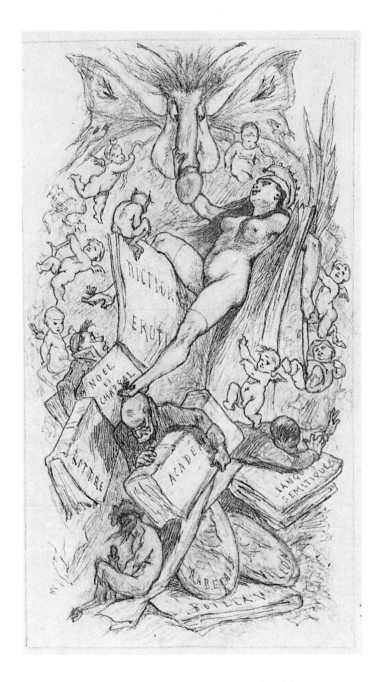

Rops Dictionaire Erotique de la Langue Française, 1861

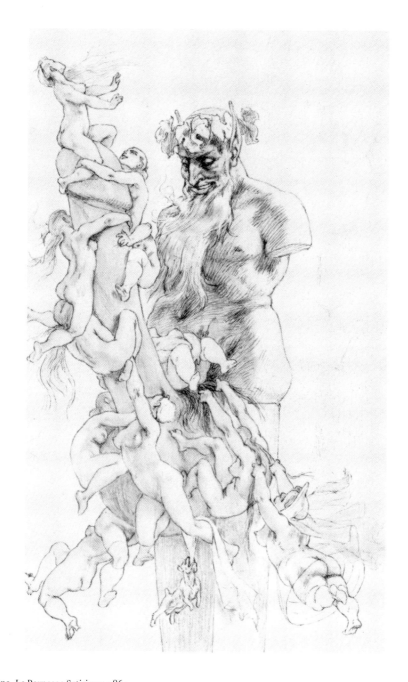

Rops Le Parnasse Satirique, 1864

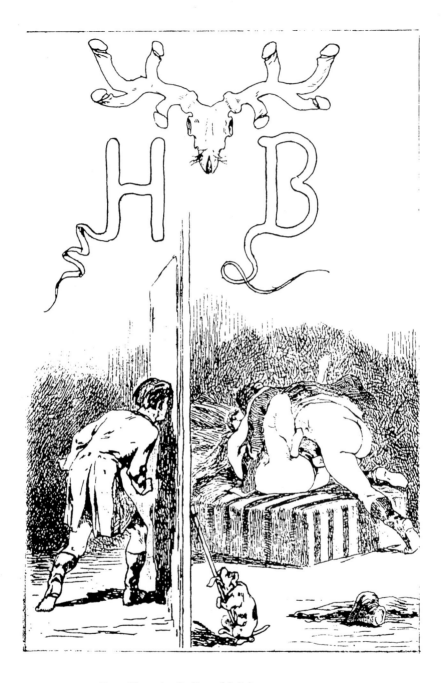

Rops Illustration for Honoré de Balzac

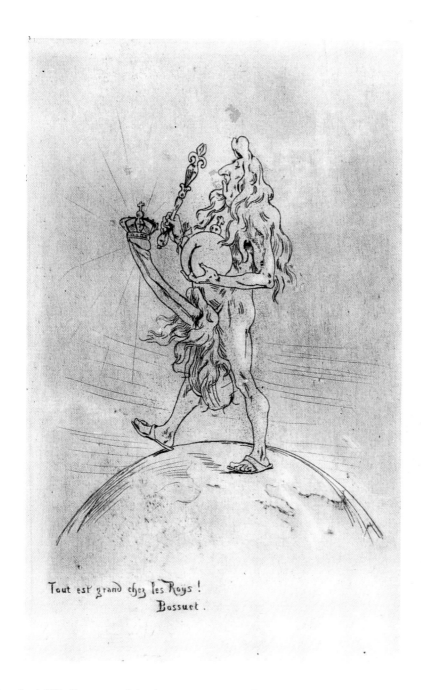

Tout est grand chez les Roys !
Bossuet.

Rops Louis XIV – Tout est grand chez les Roys! (Bossuet), c. 1893

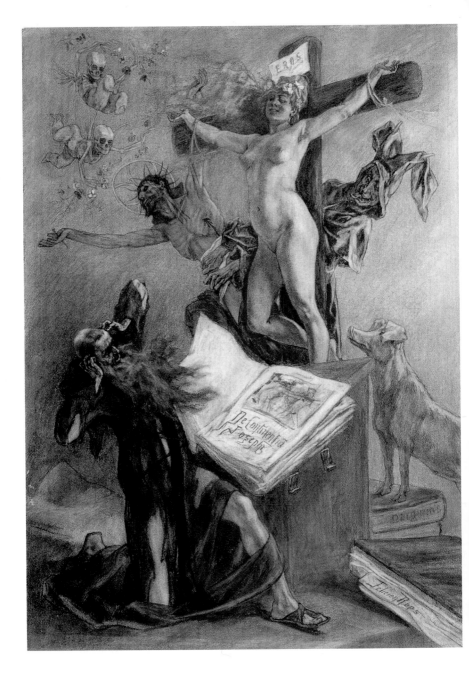

Rops La Tentation de saint Antoine, 1878

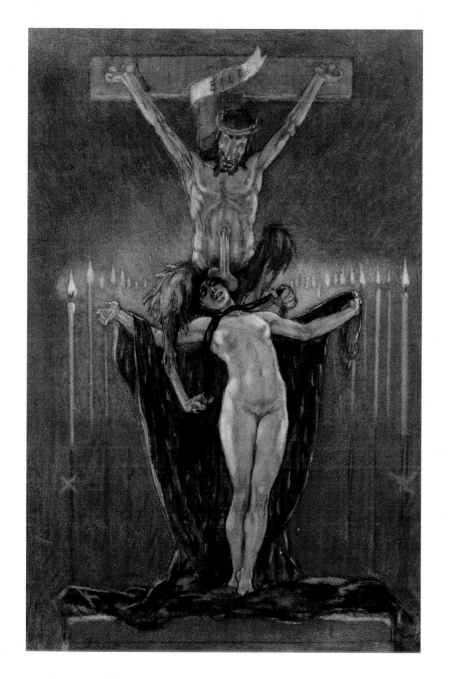

Rops Les Sataniques – Calvaire, 1882

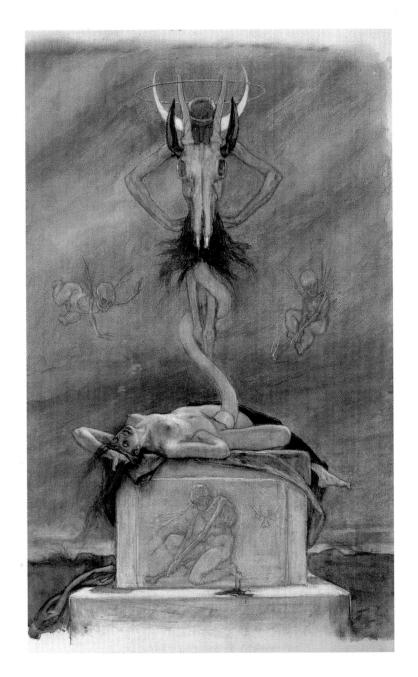

Rops Les Sataniques – L'Offrande, 1882

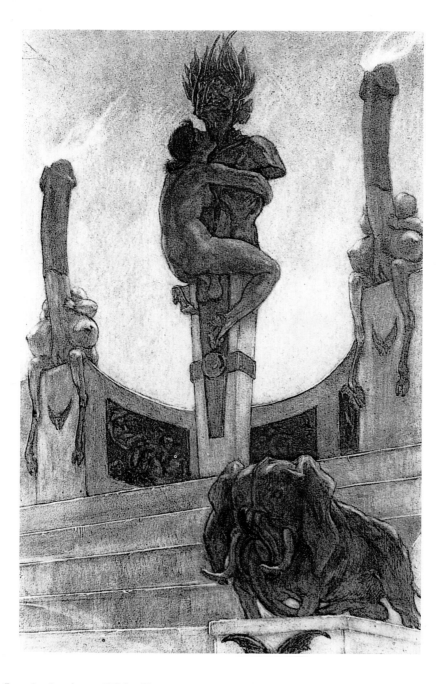

Rops Les Sataniques – L'Idole, 1882

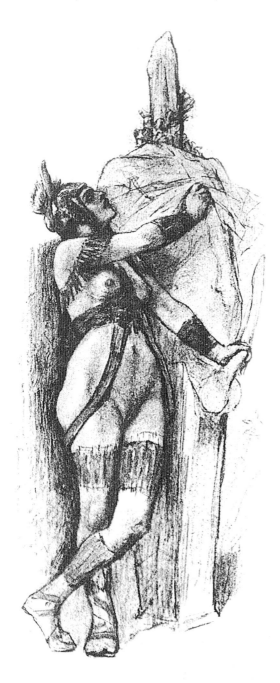
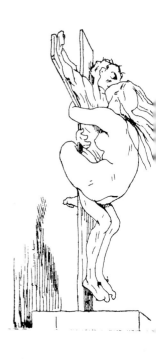

Rops L'Idole (left); Thérèse philosophe ou Vocation religieuse (right)

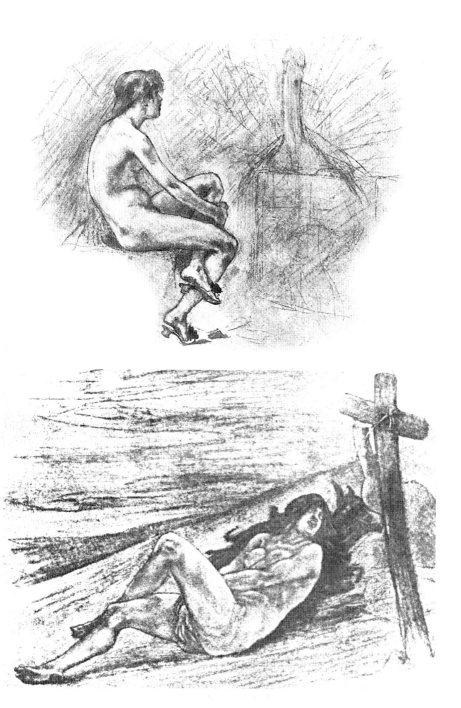

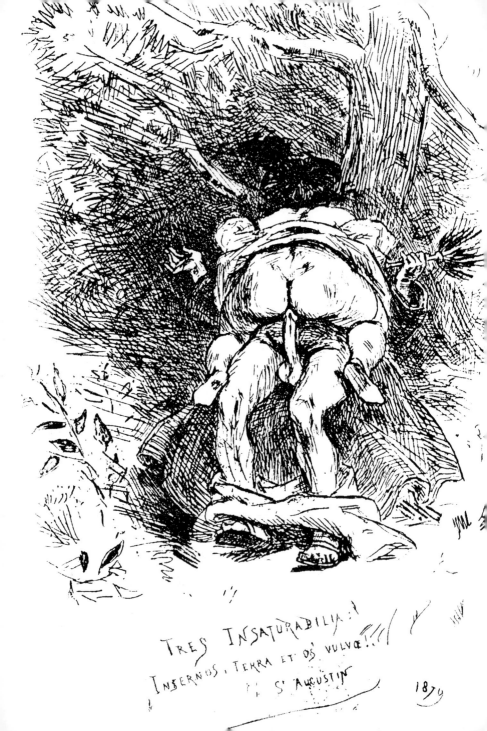

TRES INSATURABILIA :
INFERNUS, TERRA ET OS VULVÆ !!!
S⁺ AUGUSTIN

1879

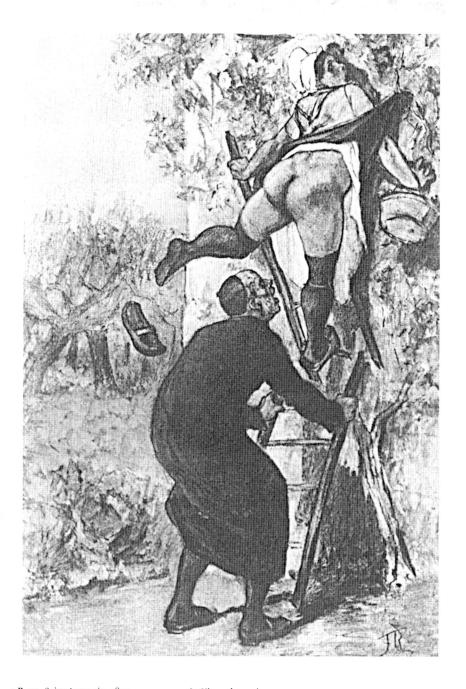

◁ **Rops** Saint Augustin, 1879 La Vigne du curé

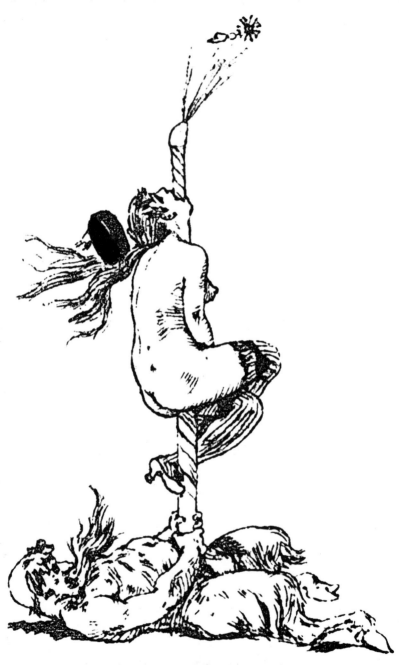

Rops La Vrille; ▷ L'Enlèvement, from the series *Les Sataniques*, 1882–1883

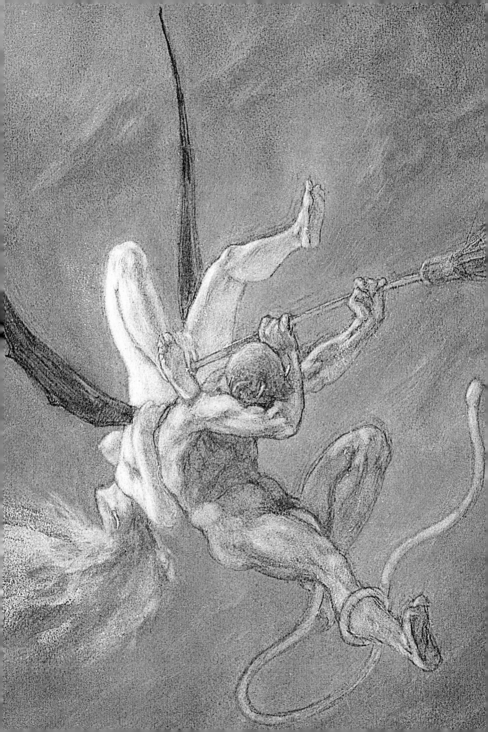

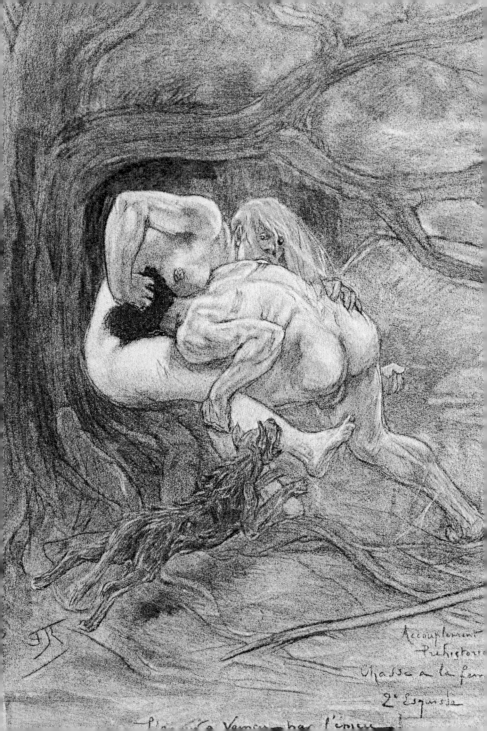

Accouplement
Préhistorique
Chasse a la femme
2ᵉ Esquisse

Plaisir à Vaincu — par l'amour !

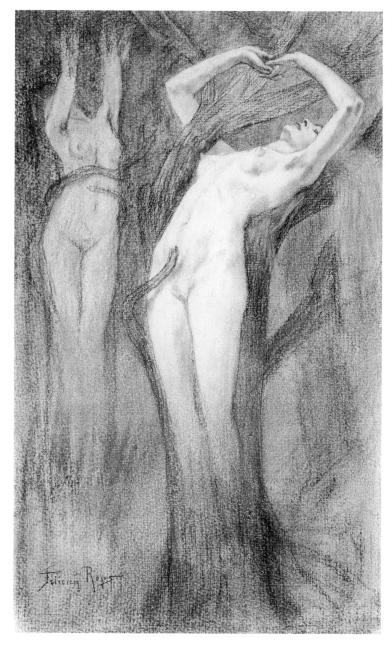

Rops Hamadryades ou La mythologie des eaux et forêts;
◁ Amours préhistoriques, c. 1878

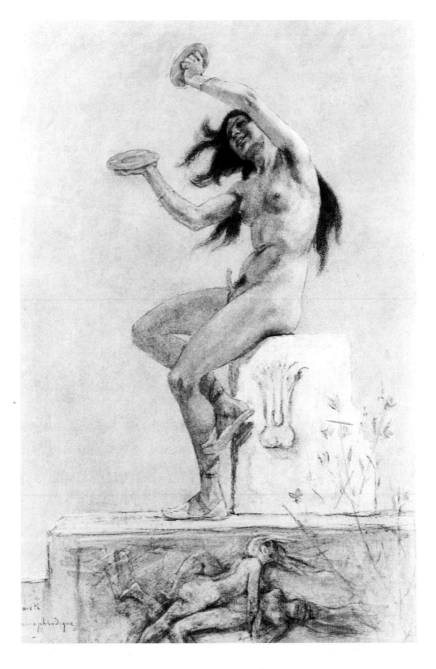

Rops Gaieté hermaphrodite, c. 1878; ▷ La Dame aux bulles

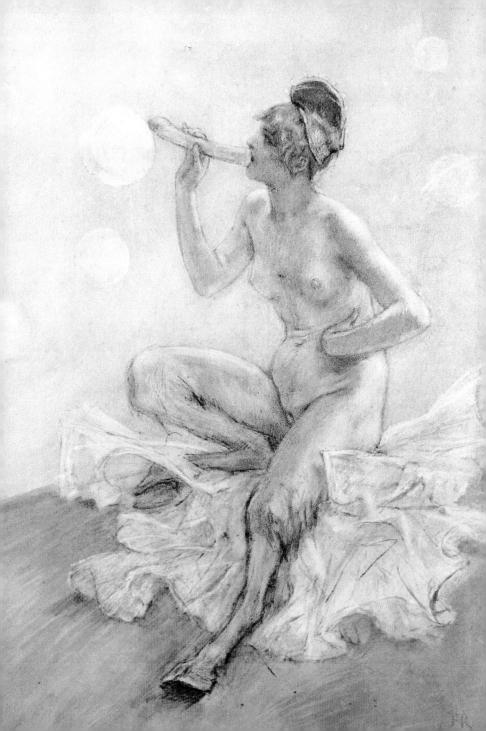

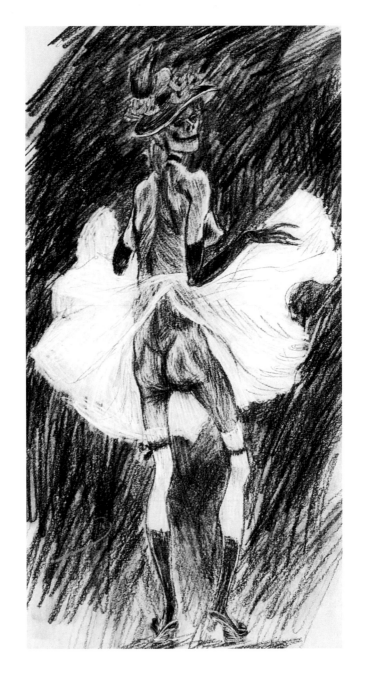

Rops La Mort qui danse, 1865

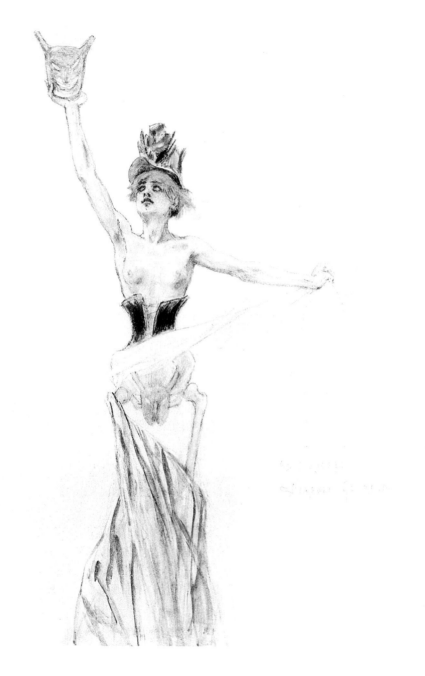

Rops Naturalia, *Ad majorem diaboli gloriam*, c. 1875

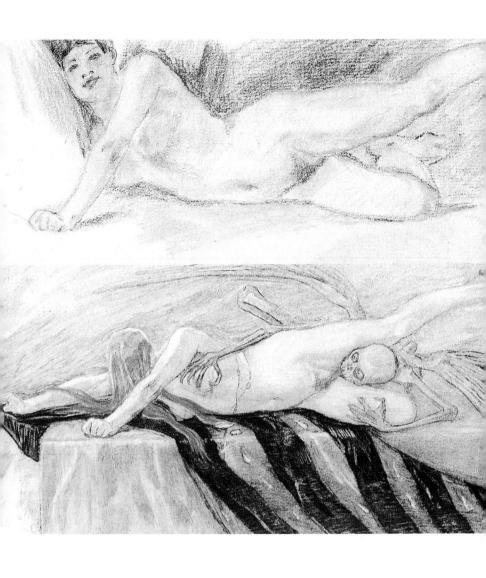

Rops Etudes d'Impudices; L'Agonie ou Mors et Vita ou sainte Thérèse (bottom);
▷ Frontispiece for *L'Initiation sentimentale* by Joseph Péladan, 1887

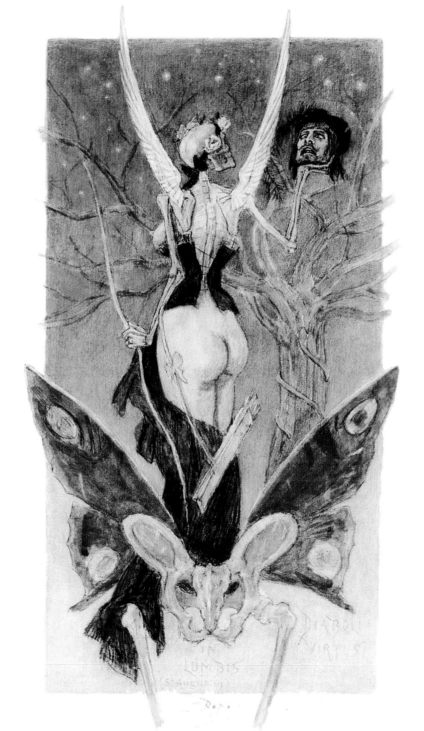

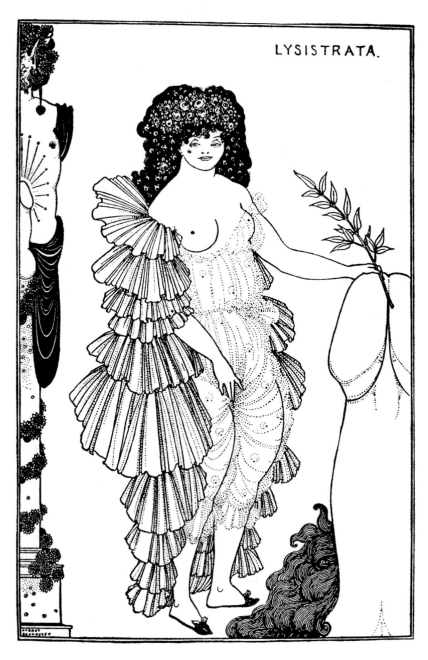

Aubrey Beardsley Frontispiece for the sequence of illustrations for
Aristophanes' *Lysistrata*: Lysistrata Shielding her Coynte. 1896

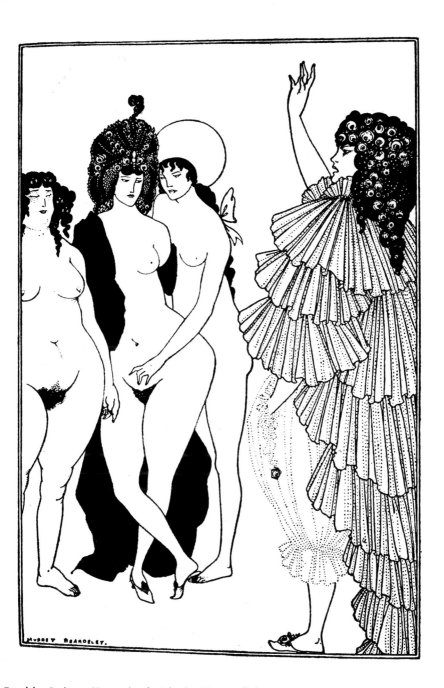

Beardsley Lysistrata Haranguing the Athenian Women, 1896

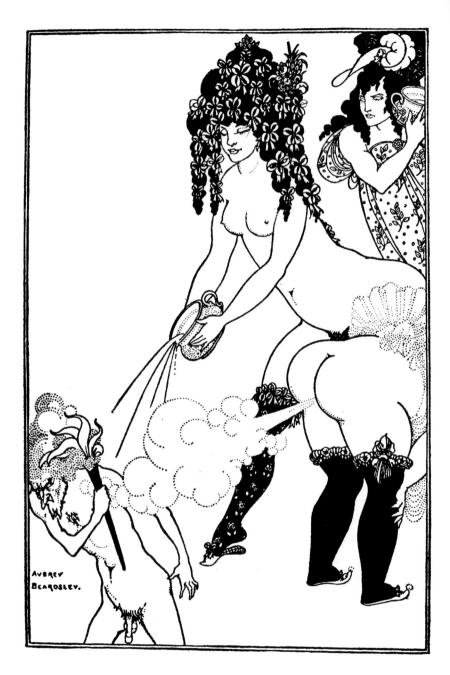

Beardsley Lysistrata Defending the Acropolis, 1896

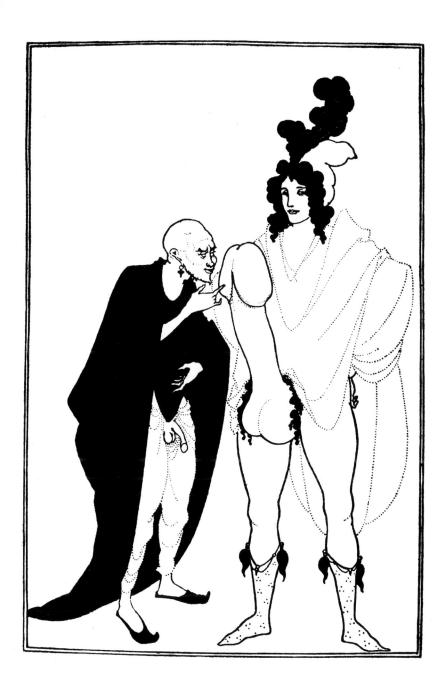

Beardsley The Examination of the Herald, 1896

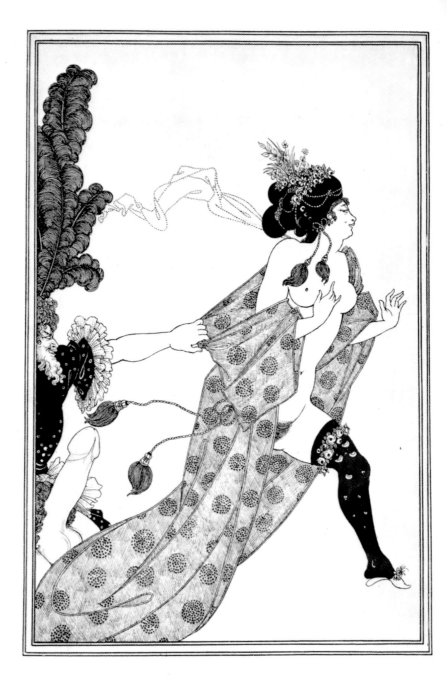

Beardsley Cinesias Entreating Myrrhina to Coition, 1896

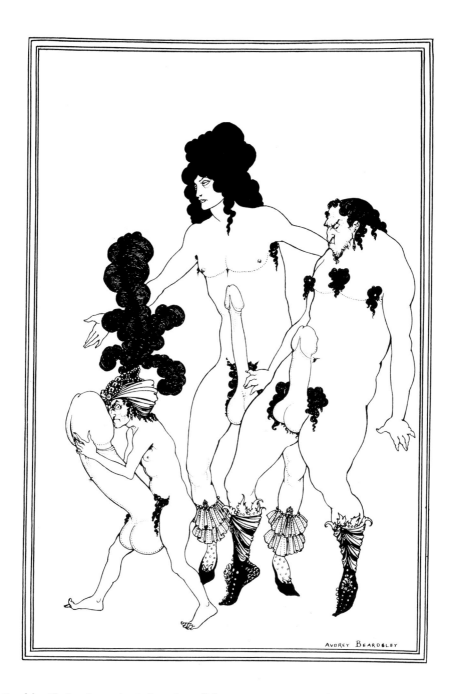

Beardsley The Lacedaemonian Ambassadors, 1896

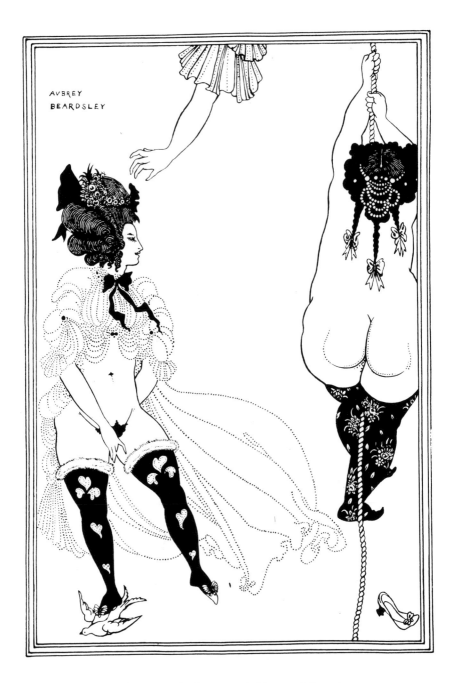

Beardsley Two Athenian Women in Distress, 1896

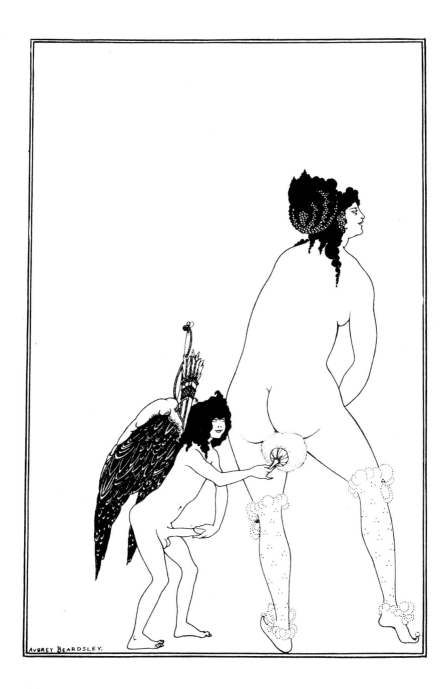

Beardsley The Toilet of Lampito, 1896

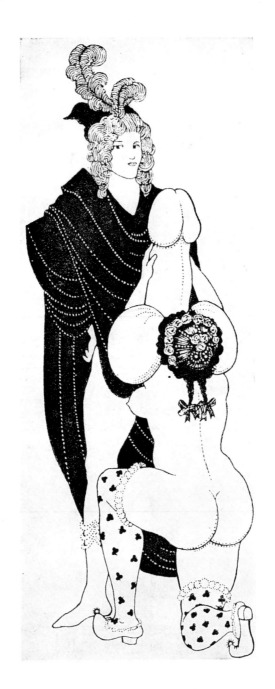

Beardsley The Yellow Book, 1894

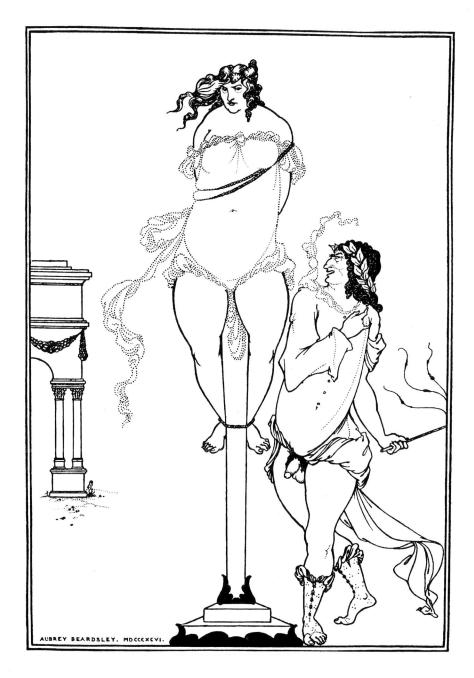

Beardsley Juvenal whipping a woman. Drawing to illustrate Juvenal and Lucian, 1897

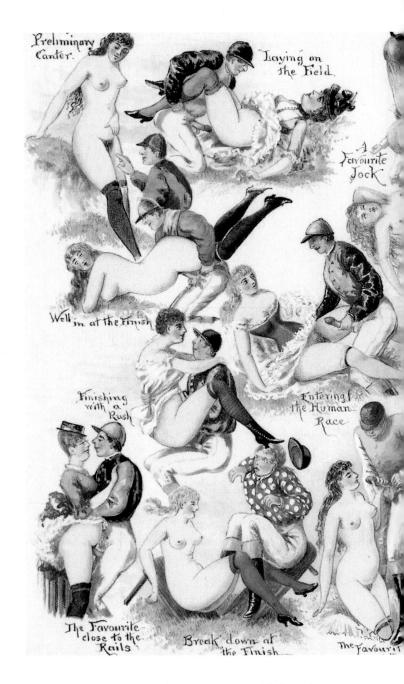

Preliminary Canter.

Laying on the Field.

A Favourite Jock

Well in at the Finish

Finishing with a Rush

Entering the Human Race

The Favourite close to the Rails

Break down at the Finish

The Favourite

Anonymous The Secret Life of the Victorian Bourgeoisie, late 19th century

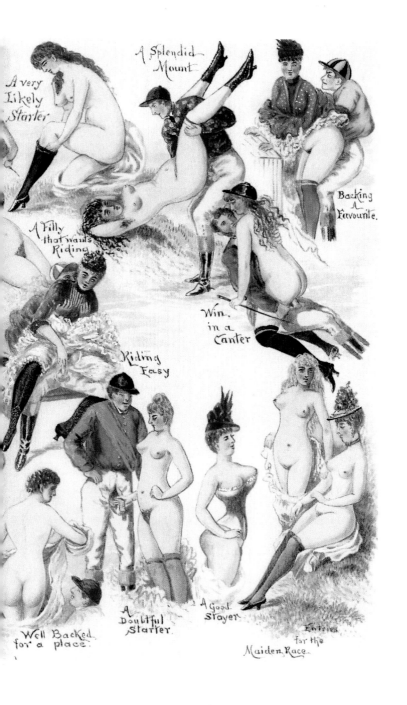

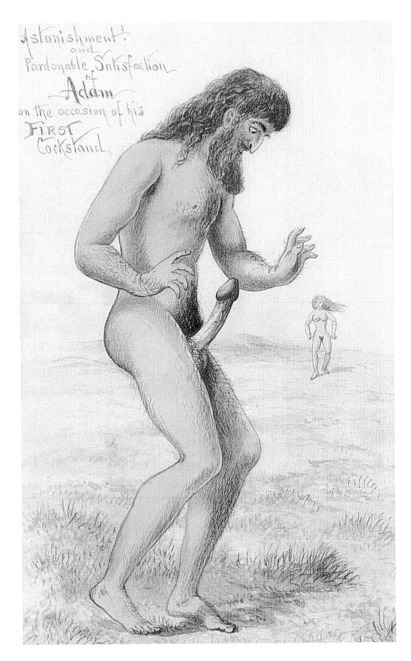

Anonymous Adam's First Cockstand, Victorian lithograph, late 19th century;
▷ La Pyramide, anonymous Victorian lithograph, late 19th century

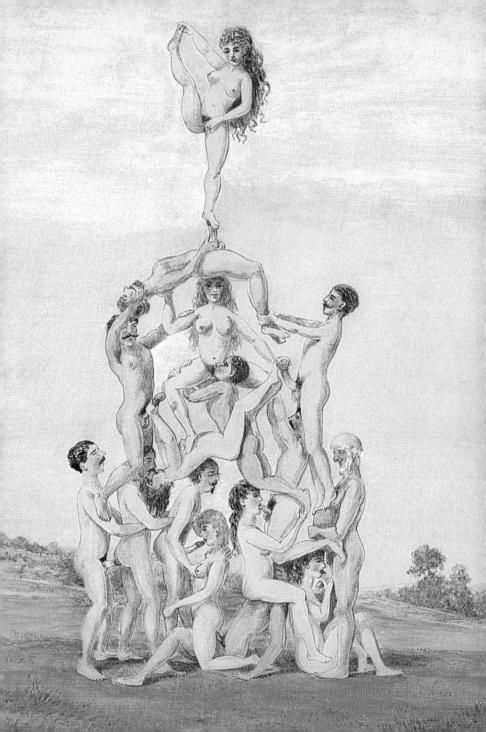

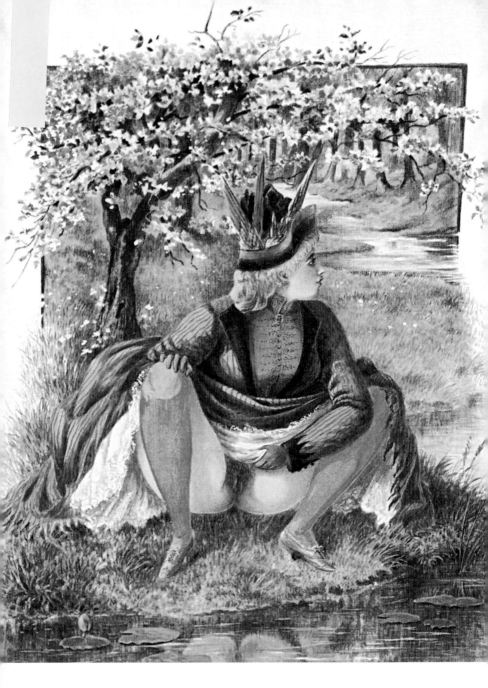

Anonymous Pissing in the Water, Victorian lithograph, late 19th century

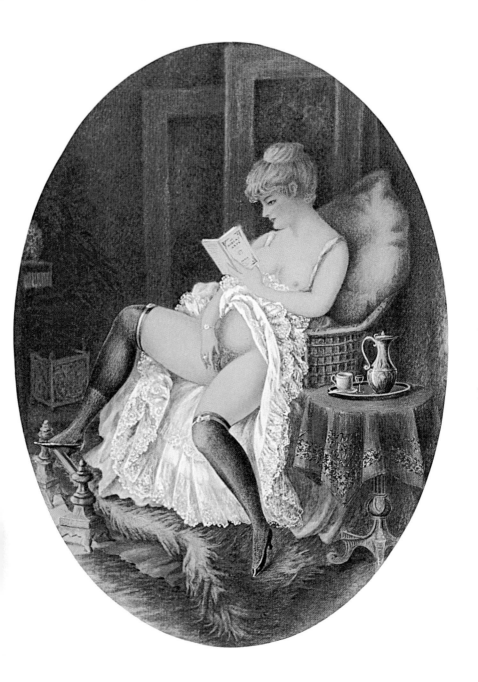

Anonymus, Victorian lithograph, late 19th century

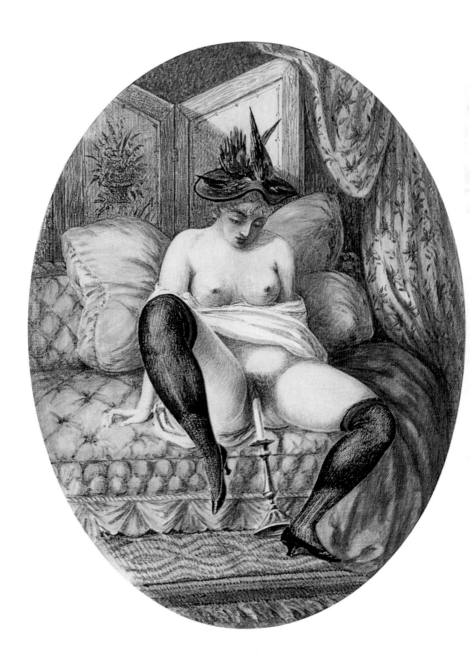

The Secret Life of the Victorian Bourgeoisie, late 19th century

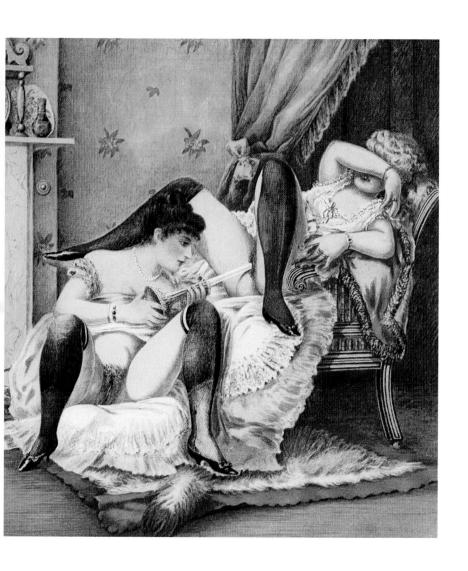

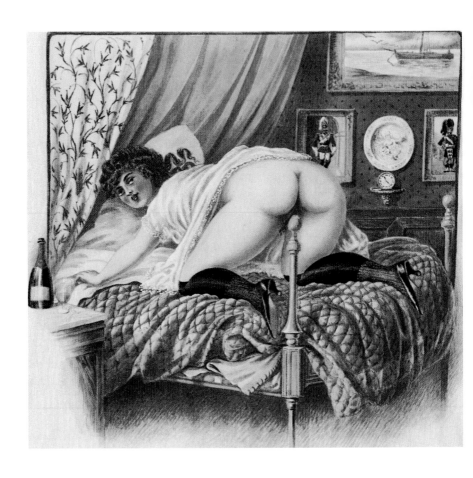

The Secret Life of the Victorian Bourgeoisie, late 19th century

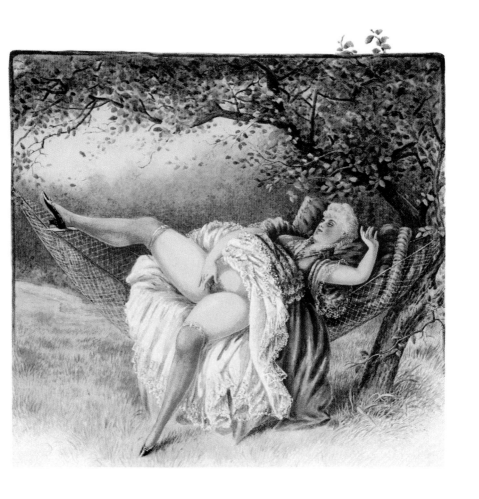

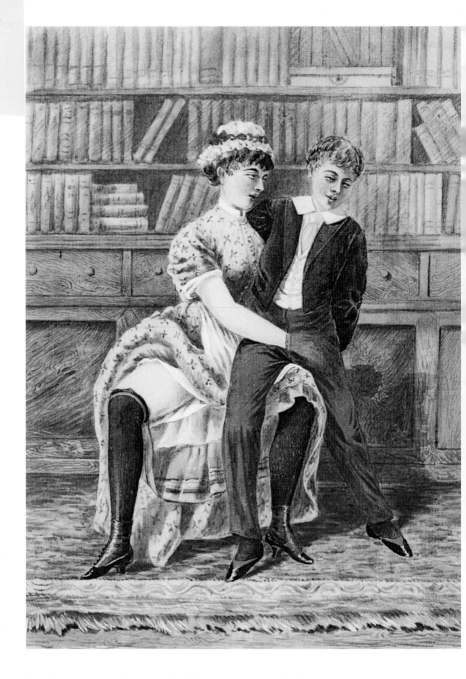

The Secret Life of the Victorian Bourgeoisie, late 19th century

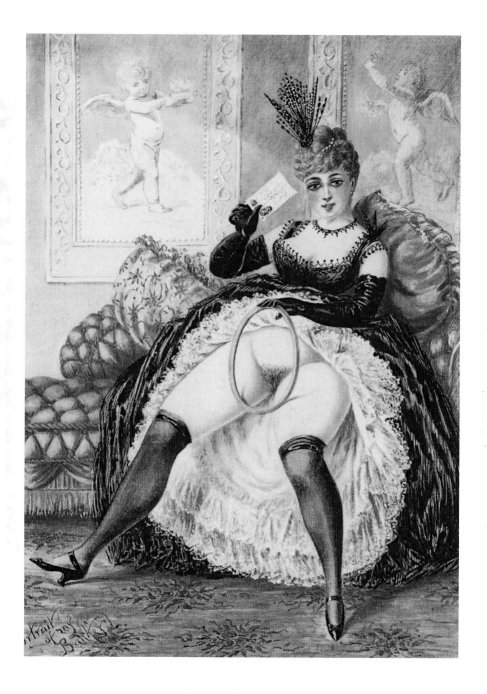

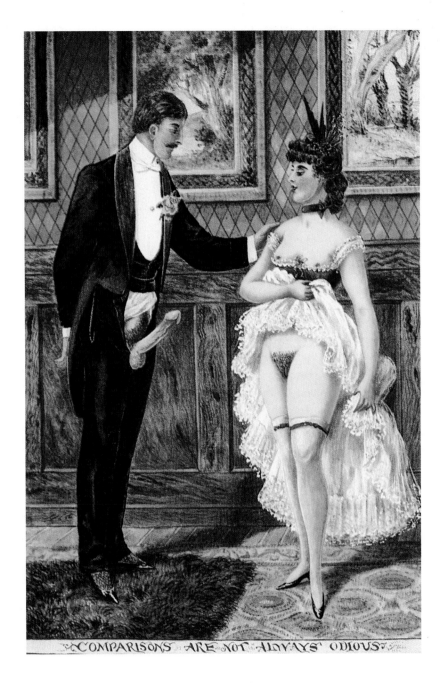

COMPARISONS ARE NOT ALWAYS ODIOUS

The Secret Life of the Victorian Bourgeoisie, late 19th century

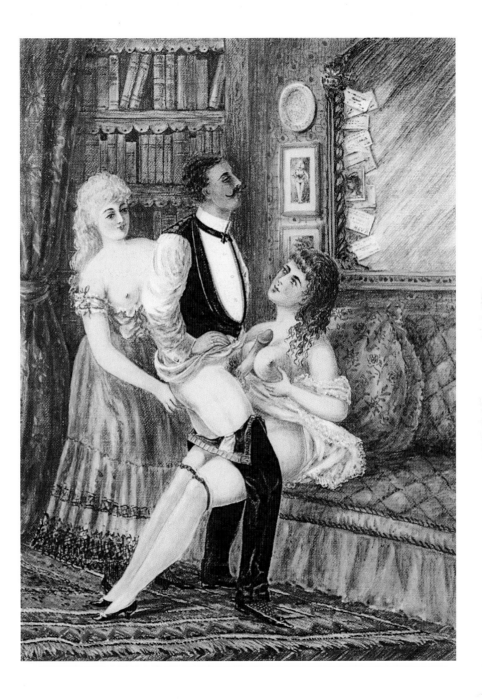

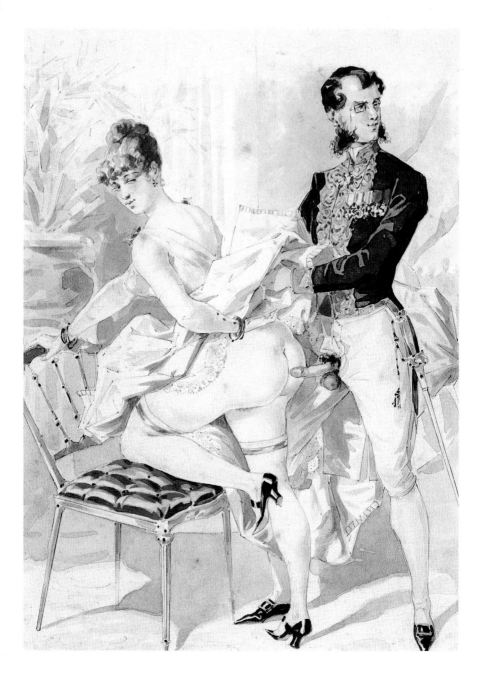

Louis Morin Watercolours, fin de siècle

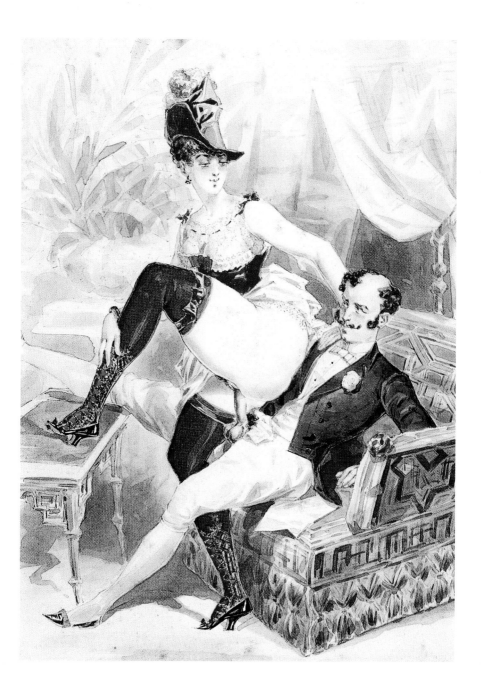

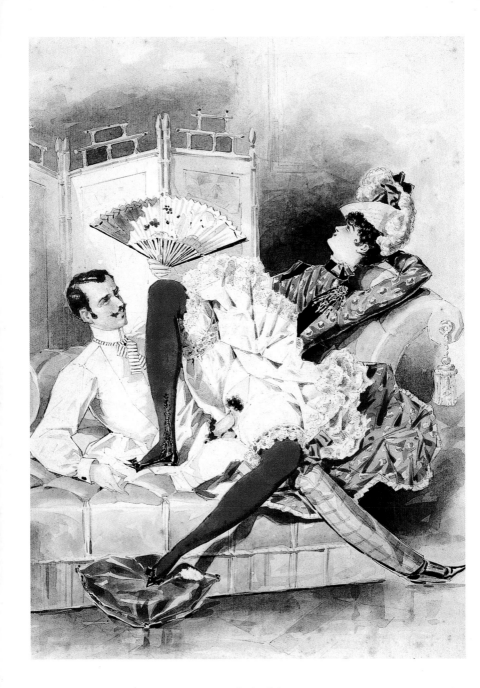

Louis Morin Watercolour, fin de siècle

FRONT AND BACK COVER: Lithographs attributed to Achille Devéria
for Alfred de Musset's *Gamiani or A Night of Excess*, c. 1848

© 2001 TASCHEN GmbH
Hohenzollernring 53, D–50672 Köln
www.taschen.com

English translation: Sue Rose, London
German translation: Bettina Blumenberg, Munich
Cover design: Angelika Taschen, Cologne
Coordination: Michael Konze, Cologne

Printed in Italy
ISBN 3–8228–5512–X

"Buy them all and add some pleasure to your life."

ICONS